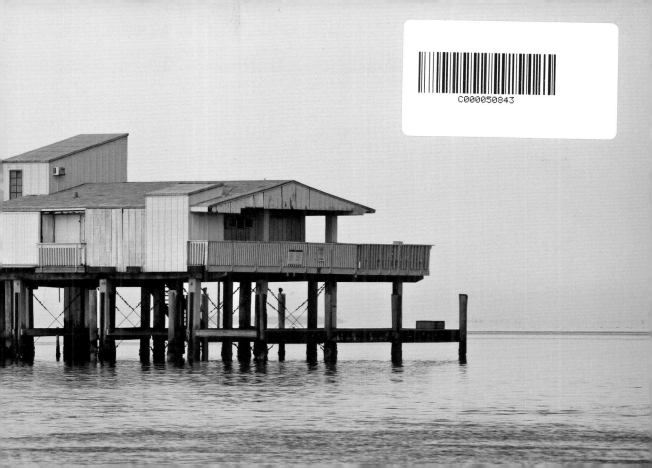

# MIAMI
## AND THE BEACHES

GERALD HOBERMAN

# MIAMI
## AND THE BEACHES

### GERALD HOBERMAN

*Photographs celebrating
the sparkling jewel of the Florida coast*

THE GERALD & MARC HOBERMAN COLLECTION

CAPE TOWN • LONDON • NEW YORK

*Concept, photography, design and production control:* Gerald Hoberman
*Text:* Gerald Hoberman
*Project Management:* Laurence Bard
*Specialist Advisor:* George Neary, The Greater Miami Convention & Visitors Bureau
*Reproduction:* Denise Geldenhuys, Marc Hoberman
*Layout:* Gerald Hoberman, Melanie Kriel
*Editor:* Marc Hoberman
*Cartographer:* Mellany Fick
*Indexer:* Ethleen Lastovica

**www.hobermancollection.com**

**ISBN: 978-191993982-7**

*Miami and the Beaches* is published for Hoberman Collection (USA) Inc. by The Gerald & Marc Hoberman Collection (Pty) Ltd
Reg. No. 99/00167/07. Unit 63, Frazzitta Business Park, Freedom Way, Milnerton 7441, Cape Town, South Africa
Telephone: +27 (0)21 551 0270/1/3 Fax: +27 (0)21 555 1935 e-mail: office@hobermancollection.com

**International marketing, corporate sales and picture library**

**United States of America, Canada, Asia**
Hoberman Collection (USA), Inc. / Una Press, Inc.
601 N Congress Ave. Ste. 201, Delray Beach FL 33445
Telephone: +1 561 542 1141
e-mail: hobermanusa@gmail.com

**United Kingdom, Republic of Ireland, Europe**
Hoberman Collection UK
Aston House, Cornwall Avenue, London N3 1LF
Telephone: +44(0) 208 3713021
e-mail: office@hobermancollection

Books may be purchased in bulk at discounted prices for corporate and promotional gifts. We also offer special editions,
personalised covers, dust jackets and corporate imprints, including tip-in pages and gold foiling, tailored to meet your needs.

**Agents and distributors**

| *United States of America & Canada* | *United Kingdom, Europe & Far East* | *London* | *South Africa* |
|---|---|---|---|
| Perseus Distribution | John Rule Sales & Marketing | DJ Segrue Ltd | Hoberman Collection |
| 387 Park Avenue South | 40 Voltaire Road, | 7c Bourne Road | 63 Frazzitta Business Park |
| New York | London SW4 6DH | Bushey, Hertfordshire | Freedom Way, Milnerton, |
| NY 10016 | Tel: +44 (0)207 498 0115 | WD23 3NH | Cape Town, South Africa |
| Tel: +1 800 343 4499 | email: johnrule@johnrule.co.uk | Tel: +44 (0)208 421 9521 | Tel: +27 (0)21 551 0270 |
| | | e-mail: sales@djsegrue.co.uk | e-mail: office@hobermancollection.com |

*Printed in China*

# CONTENTS

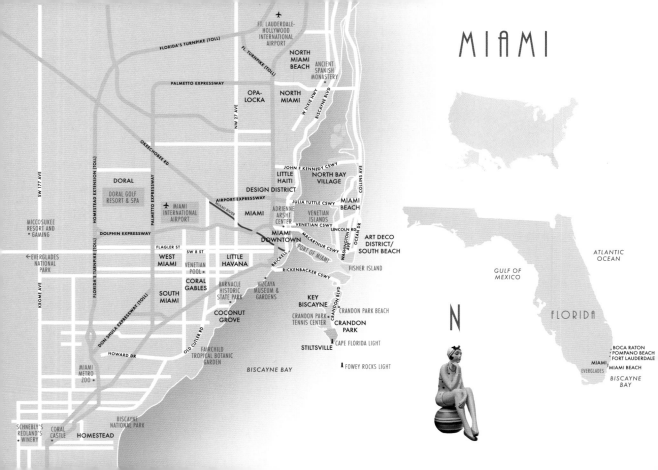

# MIAMI

FT. LAUDERDALE-HOLLYWOOD INTERNATIONAL AIRPORT

FLORIDA'S TURNPIKE (TOLL)

FL TURNPIKE (TOLL)

NORTH MIAMI BEACH

ANCIENT SPANISH MONASTERY

PALMETTO EXPRESSWAY

OPA-LOCKA

NORTH MIAMI

W DIXIE HWY

BISCAYNE BLVD

NW 27 AVE

SW 177 AVE

OKEECHOBEE RD

DORAL

DORAL GOLF RESORT & SPA

PALMETTO EXPRESSWAY

HOMESTEAD EXTENSION (TOLL)

MICCOSUKEE RESORT AND GAMING

DOLPHIN EXPRESSWAY

FLORIDA'S TURNPIKE (TOLL)

KROME AVE

← EVERGLADES NATIONAL PARK

JOHN F KENNEDY CSWY

LITTLE HAITI

DESIGN DISTRICT

NORTH BAY VILLAGE

COLLINS AVE

AIRPORT EXPRESSWAY

MIAMI RIVER

MIAMI INTERNATIONAL AIRPORT

MIAMI

JULIA TUTTLE CSWY

MIAMI BEACH

ADRIENNE ARSHT CENTER

VENETIAN ISLANDS

VENETIAN CSWY

LINCOLN RD

OCEAN DR

FLAGLER ST

SW 8 ST

WEST MIAMI

VENETIAN POOL

LITTLE HAVANA

MIAMI DOWNTOWN

MACARTHUR CSWY

WASHINGTON AVE

ART DECO DISTRICT/ SOUTH BEACH

CORAL GABLES

BARNACLE HISTORIC STATE PARK

BRICKELL

PORT OF MIAMI

SOUTH MIAMI

VIZCAYA MUSEUM & GARDENS

RICKENBACKER CSWY

FISHER ISLAND

COCONUT GROVE

KEY BISCAYNE

CRANDON BLVD

CRANDON PARK BEACH

OLD CUTLER RD

CRANDON PARK TENNIS CENTER

CRANDON PARK

HOWARD DR

FAIRCHILD TROPICAL BOTANIC GARDEN

STILTSVILLE

CAPE FLORIDA LIGHT

MIAMI METRO ZOO

BISCAYNE BAY

⚓ FOWEY ROCKS LIGHT

N

DON SHULA EXPRESSWAY (TOLL)

SCHNEBLY'S REDLAND'S WINERY

CORAL CASTLE

HOMESTEAD

BISCAYNE NATIONAL PARK

GULF OF MEXICO

ATLANTIC OCEAN

FLORIDA

BOCA RATON
POMPANO BEACH
FORT LAUDERDALE

MIAMI,
MIAMI BEACH

Everglades

BISCAYNE BAY

# ACKNOWLEDGEMENTS

*It has been a great privilege to have met and worked with so many wonderful people and organizations in Miami during the photography and production of this book. Without exception, they have been friendly, enthusiastic and supportive and I shall remain ever grateful to them. A special thank you to Laurence Bard. The dream of "Miami and the Beaches" would not have been possible without the support of Mayor Bower, the inspiration and guidance of Professor Paul George, Amy Tancig and her wonderful team at The Miami Design Preservation League, and Bill Talbert and George Neary of the Greater Miami Convention & Visitors Bureau as well as Barry Bard, Doug Greenhut and Julian Joffe.*

*We all have one thing in common – we love Miami!*

GERALD HOBERMAN

*A special thank you to:*

Amanda Weingarten Goodwin MIAMI CITY BALLET
Bob Freer
Brian Conesa TROPICAL EVERGLADES VISITOR ASSOCIATION
Daniel Cowan, Hydi Webb PORT OF MIAMI
David Wallack
Evelyn Brady UNITED CHRISTIAN CHURCH OF CHRIST
Florida Marlins
Iris Garnett Chase
James Collocott
Jennifer Diaz, Jennifer Haz, Charlie Haz
    GREATER MIAMI CONVENTION & VISITORS BUREAU
Joanne Leahy UNIVERSITY OF MIAMI, MILLER SCHOOL OF MEDICINE
Jo Ann Bass, Brian Johnson & Marc Fine JOE'S STONE CRAB
Joseph B. Embres US COAST GUARD, SEVENTH DISTRICT
Joslyn Cassano OFFICE OF MIAMI HEALTH SYSTEM
Kent Hamrick
Margaret Lake GUSMAN THEATER
Marc Buoniconti THE MIAMI PROJECT TO CURE PARALYSIS
Marcia Jo Zerivitz JEWISH MUSEUM OF FLORIDA
Mark Cavaliere, Elizabeth Ninomiya, Gregg Truman,
    Damion Rose SOUTH AFRICAN AIRWAYS
Mark Soyka
Marty Chandler, Sara Waldman THE GOODYEAR TIRE &
    RUBBER COMPANY

Matthias Kammerer, Tatiane Paro, Daniella Gallego
    CANYON RANCH MIAMI BEACH
Miami City Ballet
Miami-Dade Gay & Lesbian Chamber of Commerce
Miami Metro Zoo
Mitchell Kaplan BOOKS & BOOKS
New World Symphony
Peter and Denisse Schnebly SCHNEBLY REDLAND'S WINERY
Rabbi Moishe and Rivkah Denburg CHABAD OF BOCA RATON
Robert Raven Kraft
Sallye Jude, Jane Caporelli MIAMI RIVER INN
Sandra Rhyneer UNIVERSITY OF MIAMI, SYLVESTER COMPREHENSIVE
    CANCER CENTER
Stephen Lazarus
Sylvester Comprehensive Cancer Centre
Sylvia Villafaña, Irene & Irv Barr CORAL CASTLE
Tony Goldman
Tony Powell WATERWAYS/ATON
Wayne A. Muilenburg US COAST GUARD
William Amestoy DEPARTMENT OF RADIATION ONCOLOGY, CyberKNIFE
    TECHNOLOGIST, MILLER SCHOOL OF MEDICINE

*For Laurence, Joanne,*
*Leah and Noah*

# INTRODUCTION

Miami is one of the great destinations of the world. A vast tropical paradise of palm-fringed white sandy beaches along the Atlantic Ocean, with a distinctively Latin vibe – a sparkling jewel on Florida's Coast. It is a short plane ride or a pleasant sail on a yacht along the Intracoastal Waterway from New York.

Every day many thousands of visitors to Miami delight in boarding one of the gigantic luxury liners that depart in convoy, to cruise the Caribbean in grand style from the Port of Miami. Renowned as the cruise capital of the world, longer voyagers sailing "the seven seas," regularly arrive and depart from its magnificent world-class terminal.

Playground to the rich and famous from far and wide, Miami, continues to grow apace, attracting a cosmopolitan mix of diverse cultures, yielding a cornucopia of cuisine, styles and exotic pleasures.

The well preserved and much loved 1930s and 1940s Art Deco buildings of South Beach provide the backdrop for a perpetual ebb and flow of people enjoying sun, sand and surf by day and a vibrant scene by night.

Miami Modern (MiMo) continues to add to the cities proud architectural heritage. There is a strong cultural life in Miami too. The renowned Miami Ballet and the magnificent Gusman Theater are but two examples. Then there are museums, libraries and art galleries monuments, botanical gardens, an impressive zoo, universities and cutting edge medical research facilities, Miami has it all!

By way of contrast, a visit to the Everglades, a vast, truly wild tropical wilderness preserve teeming with wildlife, is a defining moment for visitors to Miami. Unique, in the whole of the Continental United States, it covers about 4000 square miles (10 000 square kilometers).

I have pleasure in presenting Miami and the Beaches to you as I see it.

*Gerald Hoberman*

**GERALD HOBERMAN**

# THE MAYOR OF MIAMI BEACH

Miami has been called many things by many people – the Capitol of the Americas, the Magic City, Casablanca. So many from all over the world have come here and each person sees their own vision of paradise in our shimmering waters, sandy beaches, and cosmopolitan culture.

As Mayor of the epicenter of it all – Miami Beach – I have watched this unique place continually renew itself on the dreams of generations of immigrants, builders, artists and would-be kings. From the largest collection of Art Deco buildings in the world to shining modern towers with breathtaking sea vistas, to the swampy edges of the Everglades, a world of possibilities is presented.

European visitors mingle with the locals on Lincoln Road. Every Latin American and Caribbean country has a Miami neighborhood nicknamed for its capitol.

New Yorkers consider us the Sixth Borough. All of these influences come out in our incredible food, vast array of cultural offerings and incomparable shopping.

We are the vanguard of the American evolution, clothed lightly in soft subtropical beauty. Fly over us with Gerald Hoberman's gorgeous photographs. They offer an enticing peek of paradise. Ours, and if you wish, yours too.

**MATTI HERRERA BOWER**
Mayor, City of Miami Beach

# THE PRESIDENT & CEO, GREATER MIAMI CONVENTION & VISITORS BUREAU

We are privileged to live in Miami, a vibrant, sophisticated cosmopolitan community nestled seamlessly in a lush natural tropical paradise. Bordered by pristine beaches, palm tree-fringed and encircled by the Atlantic's aqua waters, it comes as no surprise that our destination is one of the world's most photographed. But, on that rare occasion when a photographer manages to capture a Miami that is, on one hand, familiar, yet, on the other hand, fresh and exciting, it comes as a surprise indeed. And this is the case with Gerald Hoberman's wonderful "Miami and the Beaches."

Through Hoberman's keen eye, we find the Miami we love, overflowing with its colorful mix of cultures – Caribbean, Latin American and European. Here too, is the lure of Miami Beach that entices visitors from around the world to indulge in its many offerings. But this is also our Miami envisioned in a new, original way right from the start, as Hoberman takes us on a magical blimp ride, to look down upon the colorful boats bobbing in the crystal clear water, the causeways that lace our islands and creates for us the mosaic that is our landscape.

In this book, you'll find fresh perspectives on our unique architecture, from the pastel fantasyland of South Beach's Art Deco District; to the space-age futurism of mid-Century modernism, or MiMo; to the elegant Mediterranean style that defines Coral Gables. But there is so much more as well; the breathtaking lagoon we call Biscayne Bay, which

catches the shimmering lights of our colorful skyline in its turquoise waters; the rich history of Little Havana and Little Haiti with their monuments, botanicas and bodegas;  and the farms of our agricultural legacy, still very much alive today in Homestead. From North Miami all the way south to the Everglades -- our beloved "River of Grass" replete with its unique wildlife, marshes and 'crocs -- this book is filled with the images of the Miami we love, the one that keeps tourists coming back, and convinces us locals that we are the luckiest people on earth. And, as you turn these pages, you will fully understand why we say, "Welcome to Paradise."

*Wm. S. Talbert III*

**WILLIAM TALBERT III, CDME**
President & CEO, Greater Miami
Convention & Visitors Bureau

11

# HISTORICAL OVERVIEW

## by Paul S George, PhD

**Professor of history at Miami-Dade College and**
**historian to the Historical Museum of Southern Florida**

Few cities of such youth can claim a history as eventful, significant, and tumultuous as that of Miami. From its beginnings as a tiny settlement along the Miami River to the robust international city of today, Miami has represented for multitudes of new residents a place to begin anew, a gateway to a better tomorrow.

More than 10,000 years ago, Paleo-Indians settled along the edges of south Biscayne Bay. Later, Tequesta Indians entered the lush, subtropical area and settled along its waterways.

Victims of disease, war and other dislocations, the Tequestas were gone by 1800. The area claimed few people until Henry M. Flagler, a multi-millionaire industrialist, brought his railroad to the Miami River in 1896 at the urging of Julia Tuttle, Miami's "Mother." Miami began to develop quickly thereafter powered by a feverish real estate industry and tourism. Soon real estate speculation brought people from all parts of the nation to Florida, and especially Miami. The real estate boom reached its zenith in the late summer of 1925. Beautiful developments bearing a Mediterranean style of architecture arose in areas that had only recently been farms or woodland.

The boom collapsed in 1926, followed by a monster hurricane bringing great loss of life and property damage. The entire region was plunged into a severe economic depression three years before the rest of the nation.

Miami weathered the Great Depression of the 1930s better than many other communities in part through the advent of commercial aviation and a resurgent tourism. America's entry into World War II in 1941, led to a radical shift in Miami's fortunes, as the city and other parts of Dade County became a huge training base for hundreds of thousands of members of the armed services.

Postwar Miami bustled as never before. Many veterans who had trained here during the war returned as permanent residents. Driven by a surging population, a suburban building explosion, and record numbers of winter visitors, a new boom was underway.

One of the city's most defining moments came in

1959 with Fidel Castro's takeover of Cuba, which drove hundreds of thousands of Cubans to Miami. Many were highly accomplished, leaving behind successful careers and businesses. Their presence in older Miami neighborhoods helped revitalize areas that had been suffering from an exodus of middle class residents to the new suburbs. Soon other Hispanic groups joined Cubans in embracing Miami as their new home.

In Miami's northern sector, refugees from Haiti were pouring into the old Lemon City neighborhood and transforming it into a vibrant black Caribbean community known, by the 1980s, as Little Haiti.

Despite gains realized by Miami's African Americans in the aftermath of desegregation, poverty and crime remained disproportionately high among the race, while black anger over the perceive – and real – inequities and biases of the criminal justice system led to a series of searing race riots. Adding to Miami's woes in recent decades has been the city's notoriety as a haven for drugs, especially cocaine.

For all of its problems, Miami could point to a lengthy list of accomplishments. Within the last half century, the area has become a vital medical and higher education center, as well as a cultural oasis. Downtown continues to experience a significant renaissance. The Port of Miami is the world's busiest cruise ship facility. With its shimmering skyscrapers, nearby Brickell Avenue has emerged as a center of commerce and a prestigious residential address. Coconut Grove remains one of the city's most picturesque and exciting neighborhoods. Trendy South Beach and its Art Deco District host on a daily basis the rich, the beautiful, and the famous.

With its wide array of cultures, languages, lifestyles, and festivals, multicultural Miami-Dade County, with nearly 2.5 million residents, one-third of whom are Cubans, represents one of America's most vibrant, colorful communities.

Miami has made extraordinary progress in its brief century as an incorporated entity. All indicators point to its growing importance as a nexus of trade and finance for the Americas, and as a hallowed sanctuary for peoples fleeing tyranny in our hemisphere. A major ingredient for its continued development amid unprecedented challenges will come from its willingness to draw comfort, direction, and inspiration from its proud past.

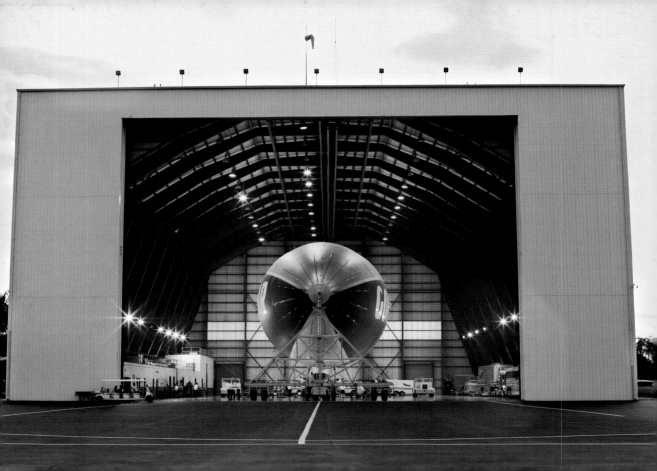

# BLIMP OVER MIAMI

The silent giant Spirit of Innovation Goodyear Blimp hovers above Miami's beaches and landmarks in a cobalt summer sky. Goodyear Blimps like this one have adorned American skies since 1925 as visible corporate icons of the world's largest tire and rubber company.

"Blimps" are small airships without internal skeletons, their shape maintained by the internal pressure of the lifting gas. According to popular folklore the term "blimp" originated from an incident where a First World War British Naval Lieutenant, Lt. A.D. Cunningham, playfully tapped the side of His Majesty's Airship SS-12 and mimicking the odd noise echoed off the taut fabric he cried out "Blimp!"

The first of Goodyear's airships were built in the 1930's to assist naval operations. With their large internal metal frames and unusual shape, they proved to be highly effective for a large range of functions including surveillance, as aerial aircraft carriers and as early-warning radar stations.

Airships are able to stay aloft for days at a time and the "Snow Bird" – a Goodyear-built ZPG-2 still holds the flying endurance record of 11 days in flight when, in March 1957, it flew from Weymouth,

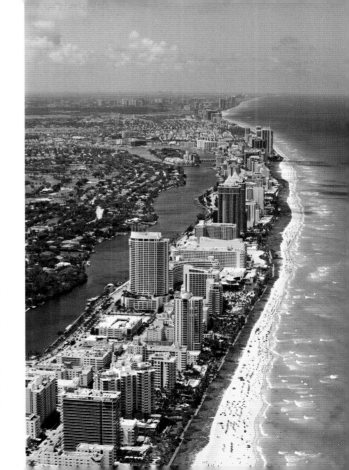

Massachusetts, to Europe and Africa and back to Key West, Florida, without refueling or landing.

Today, Goodyear operates three airships in the United States – the Spirit of America, based in the City of Carson, California; the Spirit of Goodyear, based in Akron, Ohio; and the Spirit of Innovation, based in Pompano Beach, Florida.

Squinting towards the sky to read the latest promotional message illuminated on the side of the Goodyear Blimp is a firmly entrenched Miami tradition. Today, messages are displayed via a cutting-edge LED system – the latest in a long line of innovative marketing technologies. Earlier methods included a record player, microphone and attached loudspeaker, broadcasting "Blimpcast" recordings and live greetings to the public below.

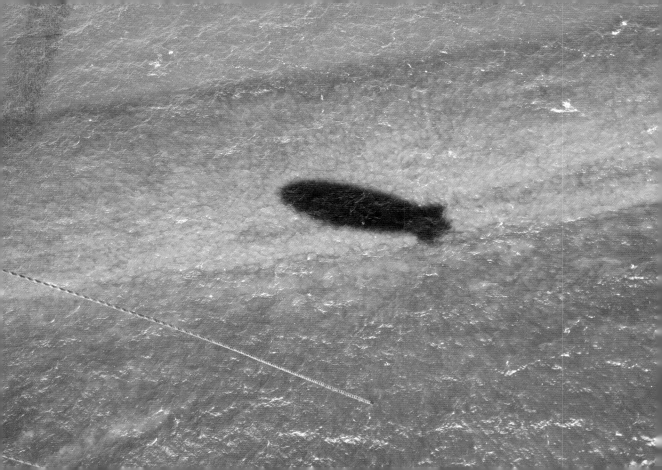

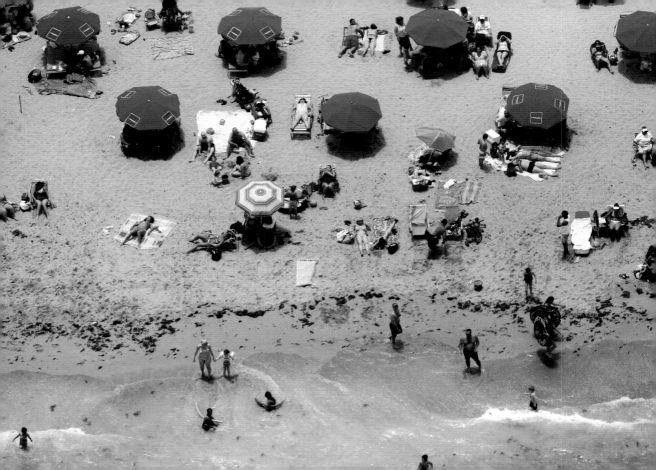

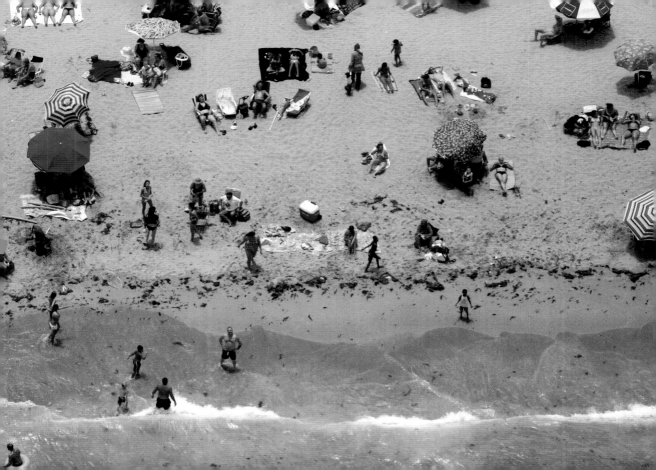

# VENETIAN ISLANDS

This remarkable artificial archipelago in Biscayne Bay connected by bridges from the Florida mainland and conveniently close to Miami Beach's South Beach and the Adrienne Arsht Center for the Performing Arts, is the epitome of privacy and opulent living. Articulated, the islands are from west to east: Biscayne Island (Miami), San Marco Island (Miami), San Marino Island (Miami Beach), Di Lido Island (Miami Beach), Rivo Alto Island (Miami Beach) and Belle Isle (Miami Beach). Flagler Monument Island, originally built in 1920, as a memorial to railroad pioneer Henry Flagler, is reserved as an uninhabited picnic and recreational spot. The original bridge linking the Islands (Collins Bridge) was constructed by John S. Collins, a farmer and developer with the financial backing of the automotive parts and racing pioneer Carl G. Fisher. At the time of its completion, it was the world's longest wooden bridge. The 2½ mile toll bridge opened on 12th June 1913, providing a vital link to the newly established city of Miami Beach, which was formally accessible only by ferry.

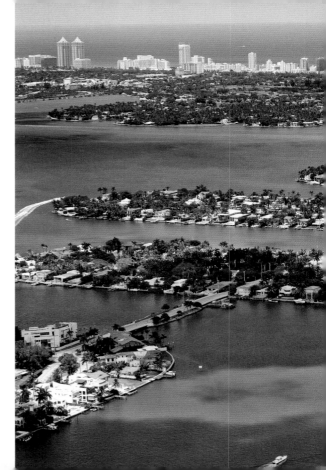

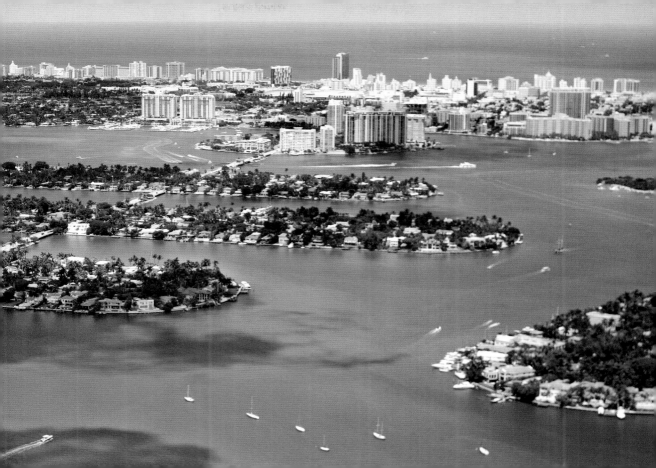

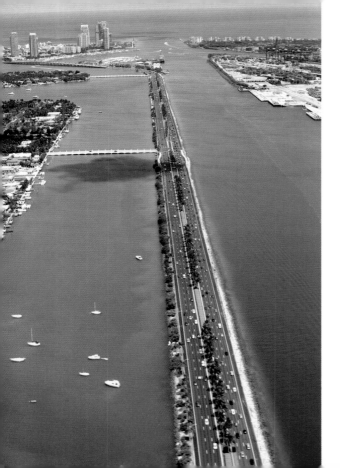

In 1925, the original wooden bridge was replaced by arched drawbridges renamed the Venetian Causeway. Nowadays the causeway is a popular place to promenade, jog and cycle.

The Venetian Islands concept was planned to be much larger than it is today. Its expansion was halted by the aftermath of the Miami Hurricane in 1926, the slump after the 1920s land boom and a strong lobby to halt "further mutilation of the waterway".

## THE MACARTHUR CAUSEWAY

This imposing 3.5 mile (5,6 km) six lane MacArthur Causeway (*left*), across Biscayne Bay, honoring World War II General Douglas MacArthur, connects downtown Miami and Miami Beach via Biscayne Bay. It is the only roadway connecting the mainland and the beaches to the neighborhoods of Palm Island, Hibiscus Island, and Star Island.

Designed by Frederic R. Harris, Inc, American Bridge Company, it was opened on 17th February 1920.

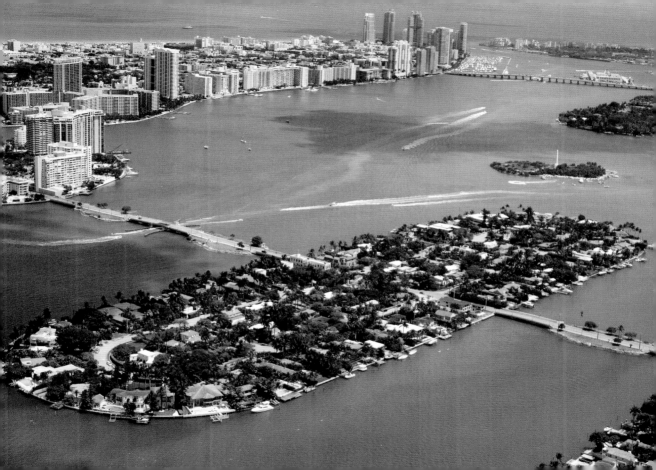

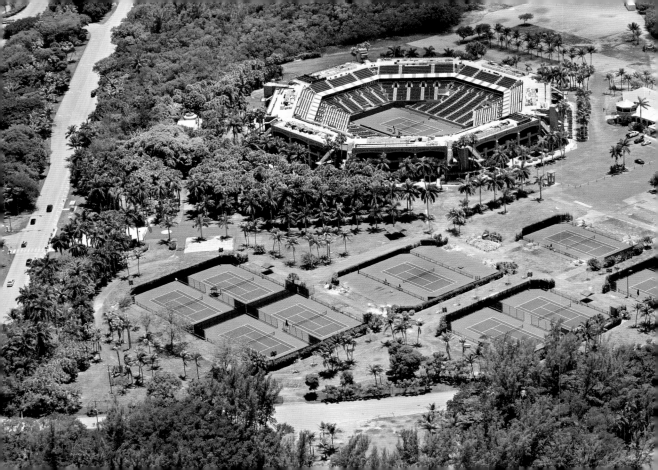

# TENNIS CENTER AT CRANDON PARK

This outstanding 13 000 seat Stadium Court is the main focus of attention at the Tennis Center at Crandon Park, home to the Sony Ericsson Open in Key Biscayne, Florida since 1987. The third home of the event, it started in Delray in 1985, moved to Boca Raton in 1986, and finally to Miami in 1987.

The venue includes 12 competition courts, 6 practice courts, with two European red clay courts, four American green clay courts and two grass courts. There are 24 luxury suits as well as state of the art facilities for the media and the players.

# BLIMP LANDING

Proceeding along the sun-drenched Florida coastline, the Spirit of Innovation Goodyear Blimp heads in the direction of its Pompano Beach base (*overleaf*). As the Blimp approaches the airfield, a long open-air vehicle with specially trained ground personnel races towards the landing site. Leaping out of the vehicle and taking their positions, each grab hold of the ropes dangling from the gargantuan air ship, tugging and guiding the craft gently into position on the ground.

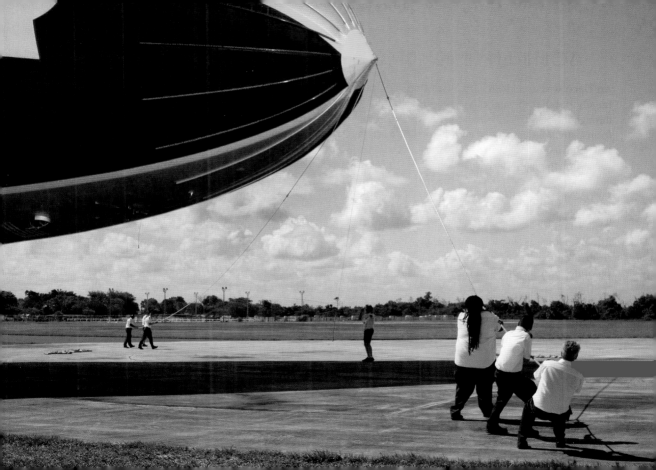

# SOUTH BEACH ART DECO

Art Deco was an eclectic artistic design style that was hugely popular throughout the world from the 1920's through the early 1940's. Characterized by bold geometric forms, streamlined shapes and exotic finishes , the Art Deco movement celebrated speed, power and opulence, replacing the soft pastels and organic forms of Art Nouveau. While Art Deco's origins were primarily European (the name "Art Deco" is derived from a shortening of *Exposition Internationale des Arts Décoratifs*, Paris's famous arts show), its impact quickly spread throughout the globe, inspiring many artistic disciplines from architecture, fashion and industrial design to painting, graphic arts and film.

There are three principal styles of Art Deco: Traditional, Streamline Modern and Mediterranean Revival inspired by European architecture. Locally the Colony Hotel on Ocean Drive, designed by the prolific legendry architect Henry Hohauser in 1935, was one of the first of a specific style that became known as Tropical Art Deco. The lobby of the hotel features a flamboyance of mint green vitrolite and an Art Deco mural above the fireplace. The Tropical Art Deco style often depicts a wealth of subject matter associated with Miami's South Beach. Stylized sunbursts, pink flamingoes, ebullient nubile women, sophisticated beaus, palm trees and the like grace its buildings. Hohausers' Streamline Modern gem, the Essex House Hotel, built in 1938, features a tour-de-force of Art Deco in the lobby and an impressive mural by self-taught artist, Earl LaPan, depicting an expansive Everglades scene above the fireplace.

Much is owed to the preservation initiatives of Barbara Capitman who in the 1970's led a dynamic campaign to recognize the value of the Art Deco buildings in South Beach. This led to the creation of the Miami Design Preservation League (MDPL), a citizen based grass-roots organization that conducts biweekly guided tours of the District and daily self guided tours by enthusiastic and knowledgeable members from its Welcome Center. The District has the proud distinction of being the first 20th Century listing in the National Register of Historical Places.

South Beach is one of the greatest concentrations of 1930's architecture in the world. It is a virtual treasure trove.

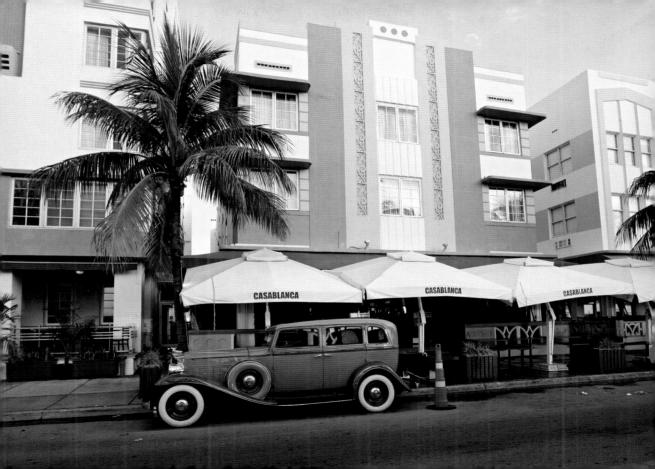

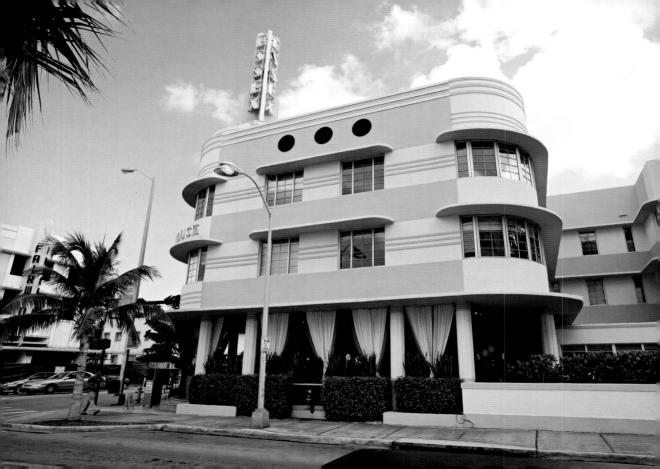

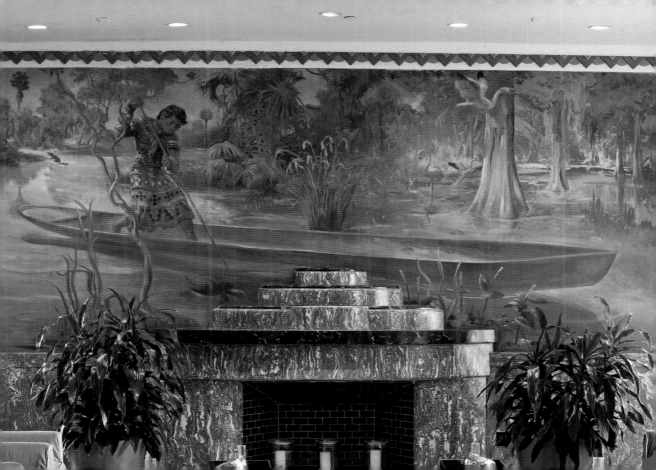

# THE COLONY HOTEL

The Colony Hotel on Ocean Drive, designed by the prolific legendry architect Henry Hohauser in 1935, was one of the first of a specific style that became known as Tropical Art Deco. The lobby of the hotel (*overleaf right*), features a flamboyance of mint green vitrolite and an art Deco mural above the fireplace.

The Tropical Art Deco style, often depicts a wealth of subject matter associated with Miami's South Beach. Stylized sunbursts, pink flamingoes, ebullient nubile women, sophisticated beaus, palm trees and the like grace its buildings.

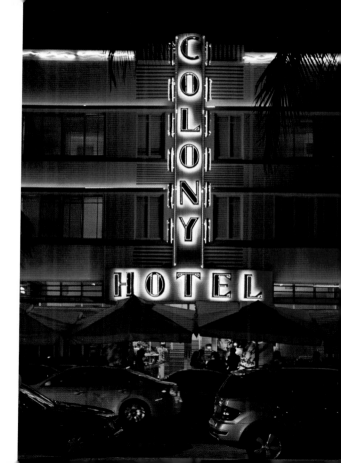

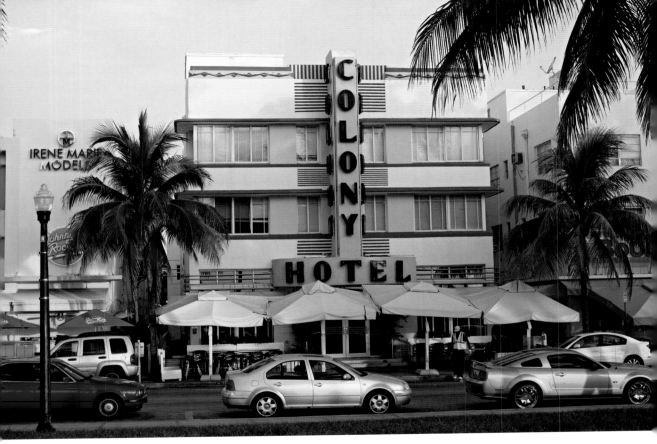

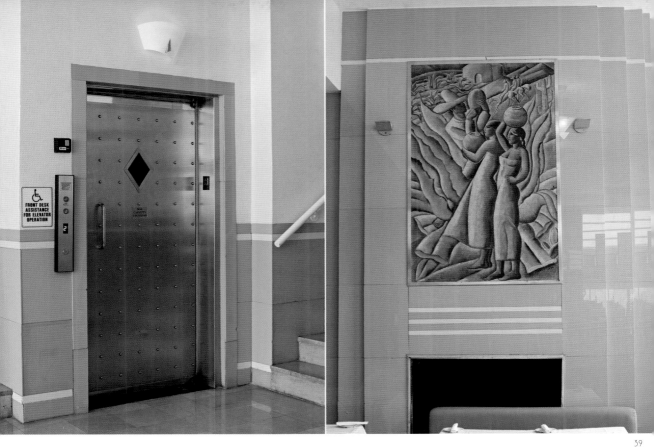

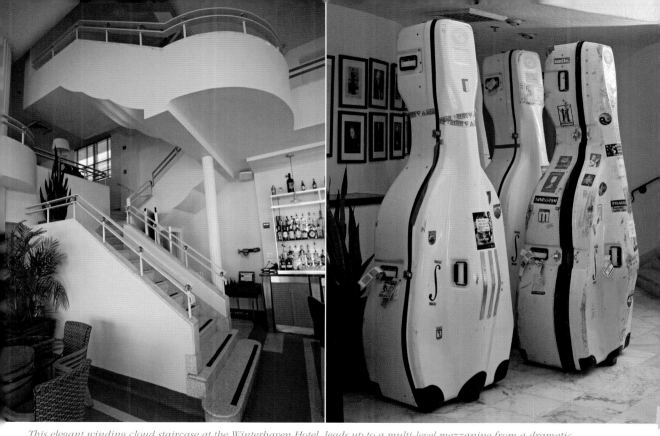

*This elegant winding cloud staircase at the Winterhaven Hotel, leads up to a multi-level mezzanine from a dramatic two-story lobby. It was designed by Albert Anis in 1939, one of the pre-eminent streamlined architects of the time.*

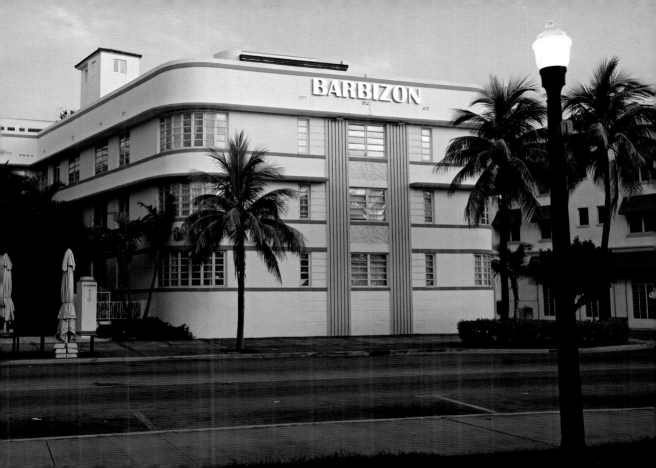

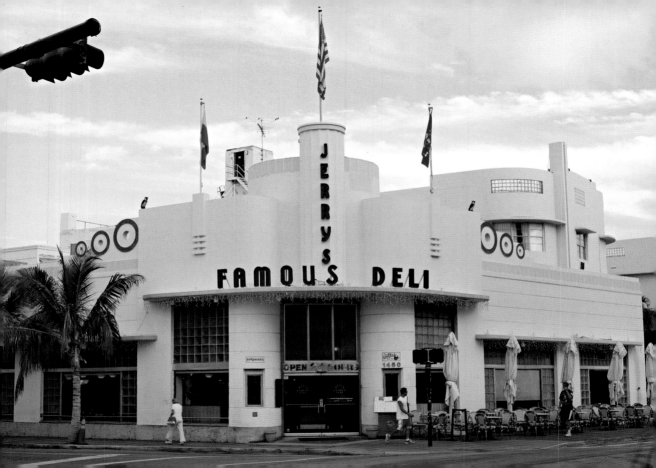

# WHERE FOOD AND PEOPLE MIX

With a menu of over 700 items, celebrity clientele, sometimes celebrity staff (comedian Andy Kaufmann once worked at the Studio City branch as a busboy) and a stock that trade as DELI, Jerry's Famous Deli is indeed famous. The original "Jerry's" was opened in 1978 by Ike Starkman and Jerry Seidman in Studio City, California. Today there are eight restaurants in Southern California and one in Miami Beach, all re-creating the nostalgic ambience of restaurants in Manhattan's theater district.

The attractive building that houses Jerry's Famous Deli (originally Hoffman's Cafeteria when it opened in 1940) is a fine example of Maximal Moderne by Henry Hohauser (1885-1963). Believed to have introduced Modernism to Miami Beach, the prolific New York trained architect, designed more than 300 buildings in the Miami area.

RIGHT: *A realistic cement owl sits perched above to a nearby building. The life-like bird is an efficient deterrent for seagulls, although ultimately amusing for wildlife photographers excited at seeing such a great photo opportunity in broad daylight!*

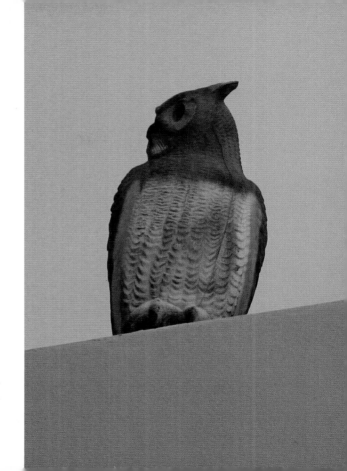

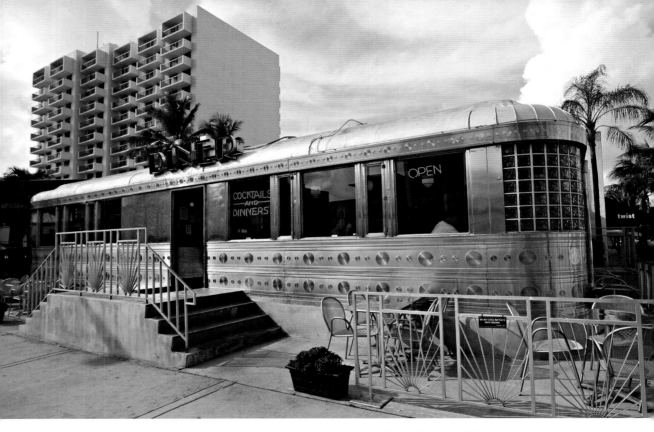

*This traditional American Deco Diner on Washington Avenue, is open 24/7 in the heart of the action.*

# ART DECO MEMORABILIA

The Miami Design Preservation League is the oldest Art Deco society in the world and has done a sterling job of preserving and protecting the historical and architectural heritage of Miami Beach. Their official gift shop at 1001 Ocean Drive is a great place to find quality Art Deco memorabilia from 1930-1950 as well as books and other related items of the period.

Purchases support the ongoing work of the MDPL, a nonprofit organization who have impeccable preservation credentials. They conduct regular walking tours of some of the best examples of Art Deco buildings under their protection on Friday through Monday mornings and on Thursday evenings. These tours provide a detailed and fascinating insight into the architectural Art Deco treasure trove that helps make South Beach unique. Self-guided auto tapes are also available for those that prefer to go at their own pace.

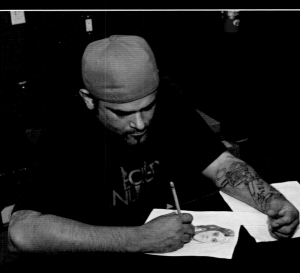
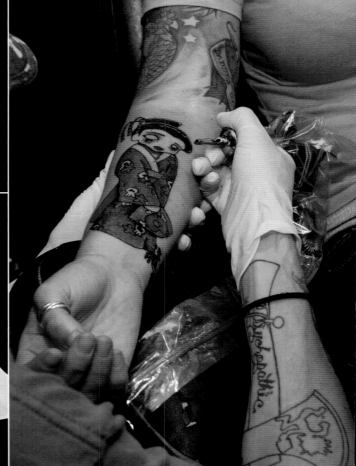

# ART DECO JEWELRY

Bakelite, a robust, lightweight, castable, fire resistant plastic, invented by Leo Baekeland in 1909, was originally used for industrial purposes and later became available in a variety of colors. Jewelry designers found it an excellent material for, eye-catching costume jewelry. Inexpensive yet sassy, it became especially popular after the Great Depression. Bakelite jewelry was at the time even sold by the legendry Coco Chanel.

The renowned and highly creative, South Beach jewelry designer, Iris Garnett Chase (*left*), reflects on the Art Deco period in a beautiful hand engraved mirror of the era. She is the author of "South Beach Step by Step", the director of retail operations for the MDPL Welcome Center and an avid collector of Art Deco furniture and artifacts. Iris creates extraordinary contemporary pieces in the Art Deco style, using genuine Bakelite from the 1930's and 1940's. Her inspired period pieces display strong geometric designs, robust colors and layered textures, with nuances of panache, humor and a touch of bygone-era bling!

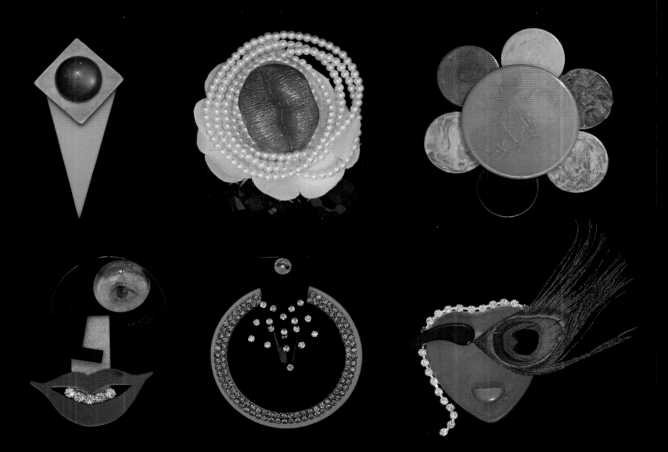

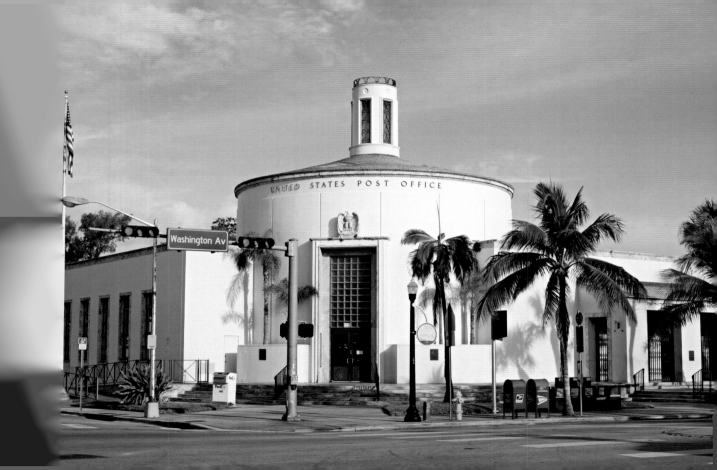

# THE POST OFFICE

Designed by Howard L. Cheney in 1937, and restored by the U.S. Post Office in 1977, this imposing corner building has a distinctive rotunda, a grand beautifully proportioned architrave with a large glass bricked fanlight and a symbolic U.S. Bald Eagle perched on the lintel above its entrance. With its splayed extension buildings on either side of the rotunda, good use is made of its corner plot.

This aesthetically beautiful U.S. Post Office is perhaps Miami Beach's best example of the Stripped Classic or Depression Moderne style – a sub-style of Streamline Moderne, reflecting a greater use of conservative and classical elements, typical of buildings commissioned by the Public Works Administration at the time.

The entrance hall has a mural on the ceiling, a circular light fitting and a large mural by Charles Hardman depicting the meeting of the Spanish Conquistadores with the Native Americans, the two groups in battle and the signing of a treaty between the Native Americans and the U.S.

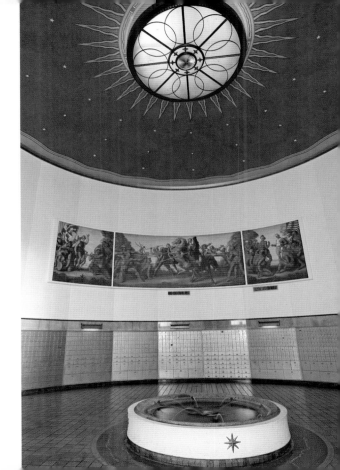

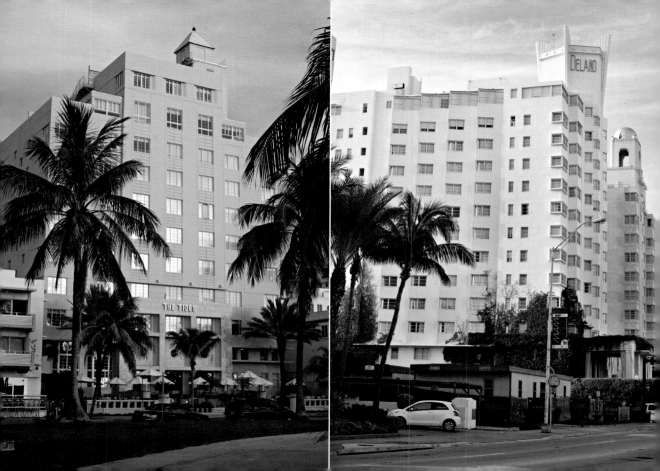

LEFT: *The elegant Tides Hotel designed by the celebrated architect Lawrence Murray Dixon, was launched as the "Grand Dame of South Beach" in 1936.*

CENTER: *Robert Swartburg's Delano Hotel was built shortly after World War II. It is an example of the transformation from Art Deco to MiMo. The interior was refurbished by Philippe Starck in 1994 in the grand tradition of Miami Beach hotel lobbies of the 1990s.*

RIGHT: *Casa Casuarina, the Gianni Versace House, where the famous fashion designer was tragically shot as he returned from his daily walk in 1997. Andrew Cunanan, a serial killer, committed suicide shortly after the senseless murder.*

OVERLEAF: *The Raleigh Hotel, an iconic 1940s Art Deco masterpiece by Lawrence Murray Dixon. The celebrated pool in the form of Sir Walter Raleigh's coat-of-arms, is one of a kind and represents the pinnacle of his illustrious career.*

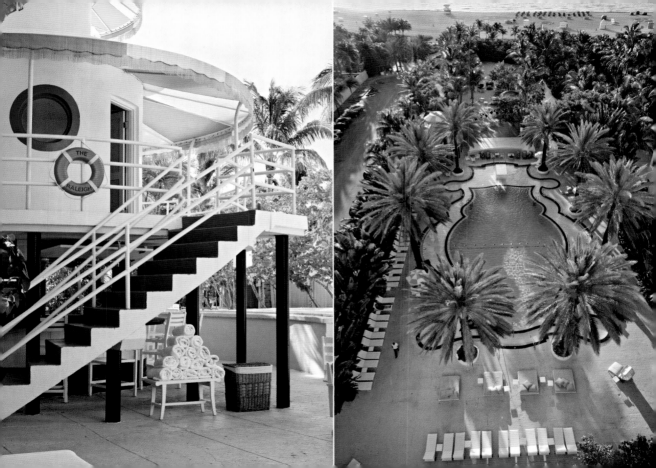

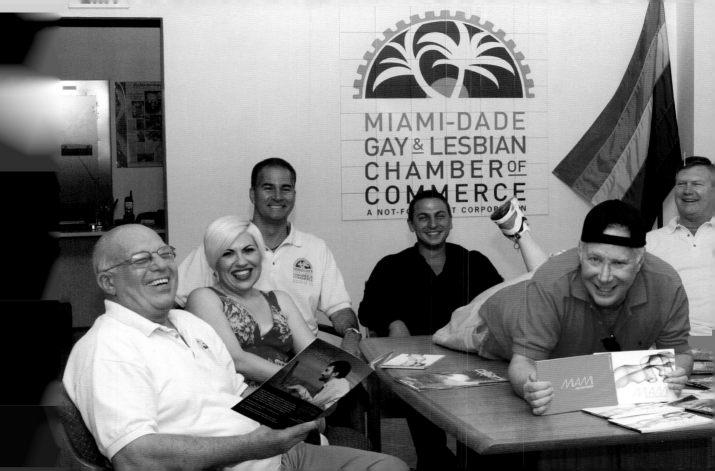

# GAY & LESBIAN FRIENDLY MIAMI

Miami-Dade Gay & Lesbian Chamber of Commerce opened its Visitors Center in April 2010 in the Historic City Hall (*overleaf*). Their mission is to promote a unified and thriving gay and gay-friendly business and professional community in Miami-Dade.

Miami-Dade is one of the pre-eminent gay and lesbian friendly destinations in the United States. The MDGLCC headquarters provide a place of community, information, resources and business networking for the estimated 1.2 million gay and lesbian travelers who visit Miami-Dade County each year as well as the estimated 183 000 gay and lesbian residents that call Miami home. It is estimated that $1.7 billion is spent by the Gay and Lesbian community in Miami-Dade County each year.

Couples walk freely down Lincoln Road or Ocean Drive hand-in-hand and are warmly welcomed by shops, hotels and restaurants. It is believed this relaxed friendly and non-judgmental attitude will attract an ever- greater number of visitors to Miami, with its exciting annual events such as the Winter Party, Art Basel Miami Beach, the South Beach Food & Wine Festival and the Art Deco Weekend.

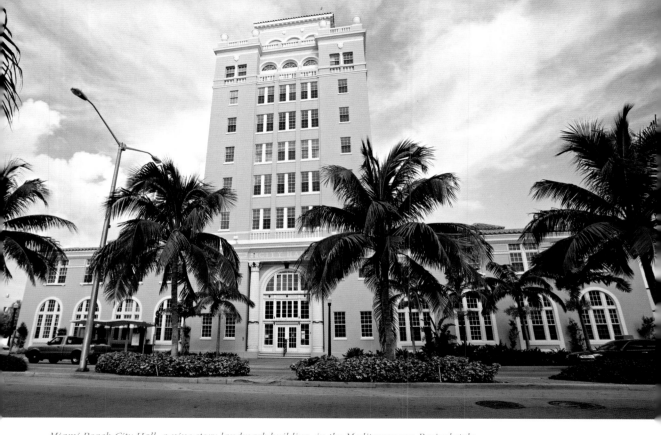

*Miami Beach City Hall, a nine story landmark building, in the Mediterranean Revival style.*

*The City Hall was designed by Martin Luther Hamilton in 1927.*

# VOLLEYBALL ON SOUTH BEACH

Everyone is welcome to play (doubles) on the soft white sandy volley ball courts, flanked by tall palm trees near 8th Avenue on Ocean Drive.

Athletic sun-bronzed Adonis's and bikini-clad girls, part of the South Beach scene, leap high into the air and dive spectacularly skywards and horizontally after the ball. The first court was set up back in the 1980's by local players.

Sun, sea, sand and surf the pristine beaches of South Beach are legendary (*overleaf*). Large ocean-going vessels and sail boats on the distant horizon provide a romantic backdrop to the vivid lifeguard huts, beach umbrellas and trendy people enjoying themselves.

LEFT: *A perpetual ebb and flow of visitors wait their turn to be photographed in front of this landmark Art Deco clock on Ocean Drive.*

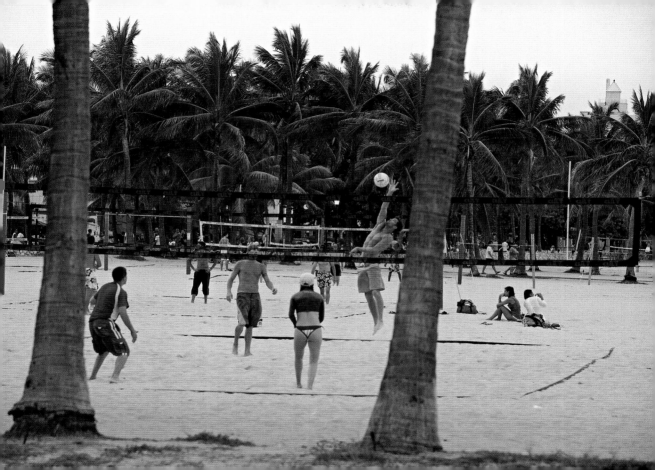

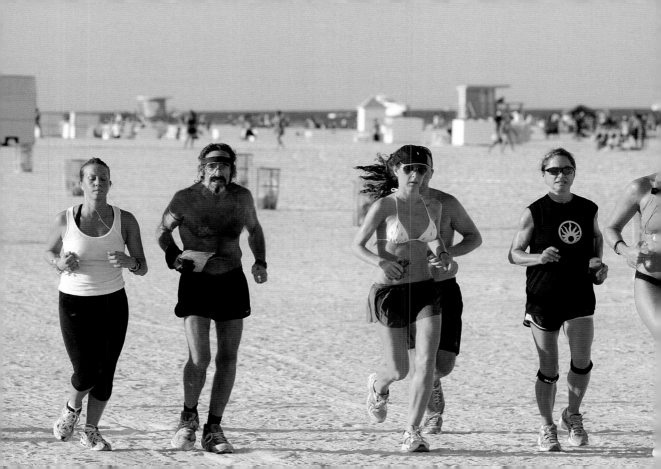

# RAVEN RUNNER

Robert Raven Kraft is a living legend and a South Beach celebrity. For the last 35 years he has run (and continues to run) 8 miles along one of four different routes on South Beach, come rain or shine without ever missing a single day from 1st January 1975 to the present, already passing the 100 000 mile mark! He usually ends the day with a one third of a mile swim in the Atlantic Ocean and during this time has never missed a South Beach sunset or been subjected to rush hour traffic.

Robert was once an aspiring young songwriter in Las Vegas and Nashville who became disillusioned with the music industry. Angry and disappointed he came to South Beach and stayed near a 5th Street gym where boxers trained and ran regularly on South Beach. He started to run part of the way with them, found it cathartic and slowly built up to do 8 miles every day. He took a New Years resolution to never miss a day for a full year. The rest is history.

A solitary runner for the first 8 years, he went on to inspire and attract a large following. Over 700 runners from more than 60 different countries and 48 states, from ages 9-79 have completed an 8 mile run with him. Each have been recorded and rewarded by nicknames such as Gringo, Angry Man and Sailor and experienced the social interaction and the sheer joy of being a "Raven Runner" on South Beach. Every day a different group of runners, many sporting the black T-shirt with the "Raven Runners" insignia, leave from the 5th Street lifeguard stand shortly after 5pm and in winter shortly after 4pm. The routes all include a run passed the pier at the southern tip of South Beach.

# LIFEGUARDS & HUTS

All delightfully different, vibrant and colorful, the 25 whimsical lifeguard stands, from South Point Park to 85th Street, characterize the *joie de vivre* of Miami's South Beach (*overleaf*). The elite, highly trained lifeguards manning the stations and their support teams are imperative to the safety of swimmers and beach-goers. Constantly vigilant, they warn bathers of any perverse prevailing conditions through a system of different colored flags, which they fly from their respective stations.

*cont. 2nd overleaf*

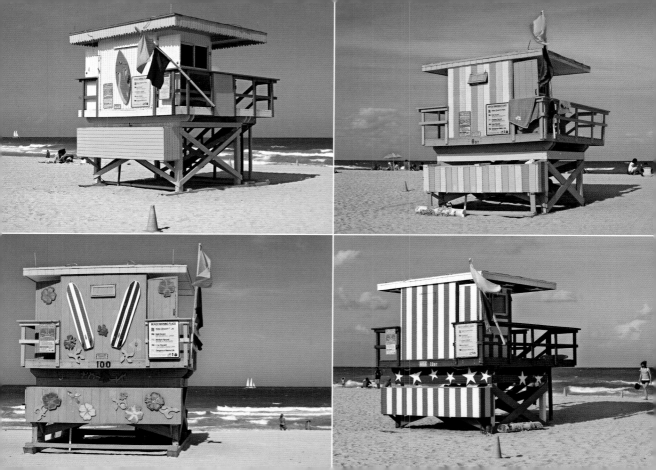

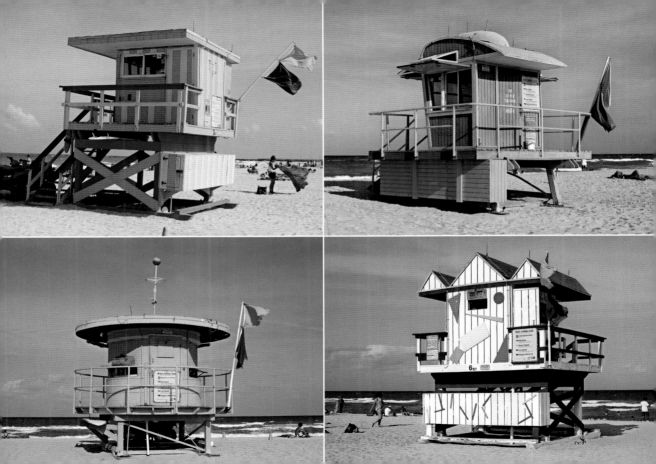

*cont. from p69*

A green flag for calm surf conditions, a yellow flag for moderate surf conditions (exercise caution), yellow flag with a black jelly fish for Portuguese man-of-war (jellyfish) present, purple for sharks and other dangerous marine life, red for strong surf and strong currents, and a red flag with the swimmer crossed out for water closed to the public.

When the call for rescue comes, the lifeguards dash off with impressive speed using 4 wheel drive vehicles, all terrain cycles, a 27 foot rescue vessel or a smaller jet-propelled craft as needed to reach the distressed and drowning in the shortest possible time. They are in constant radio contact with each other as well as the City's fire and police departments.

OVERLEAF LEFT: *Miami Beach Patrol Ocean Rescue Headquarters is located in the heart of the City's Art Deco District. Designed by Robert Taylor in 1934, it is a renowned example of Nautical Deco styled architecture, reminiscent of a ship waiting to be re floated on the next high tide.*

OVERLEAF RIGHT: *Jetty Tower*

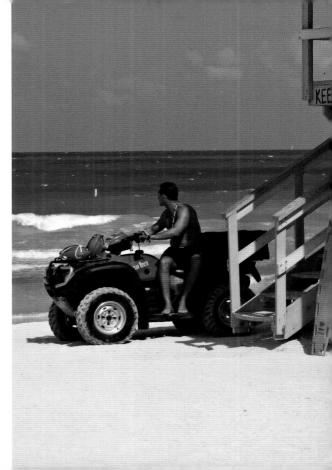

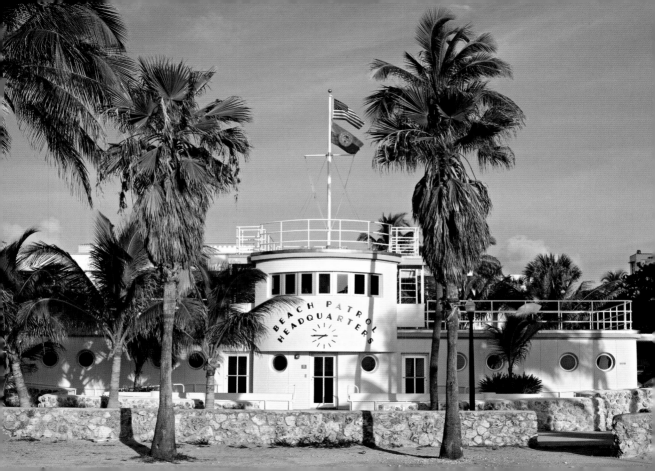

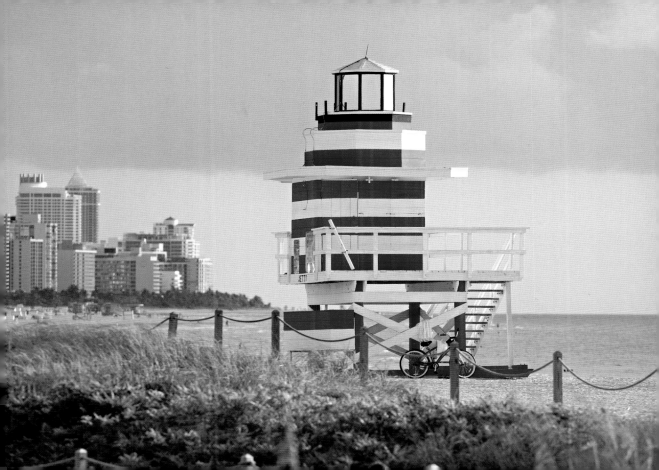

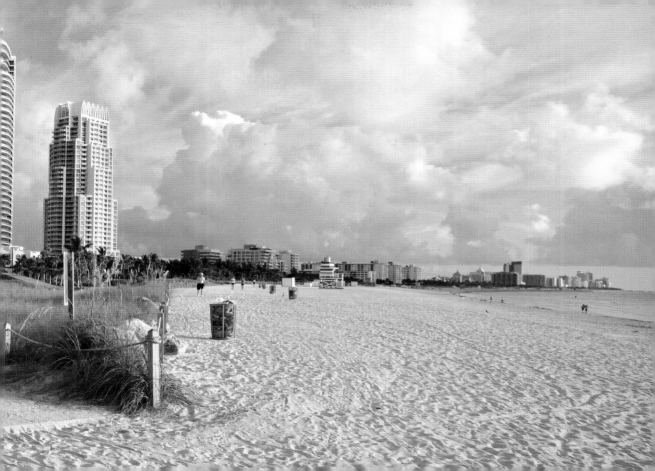

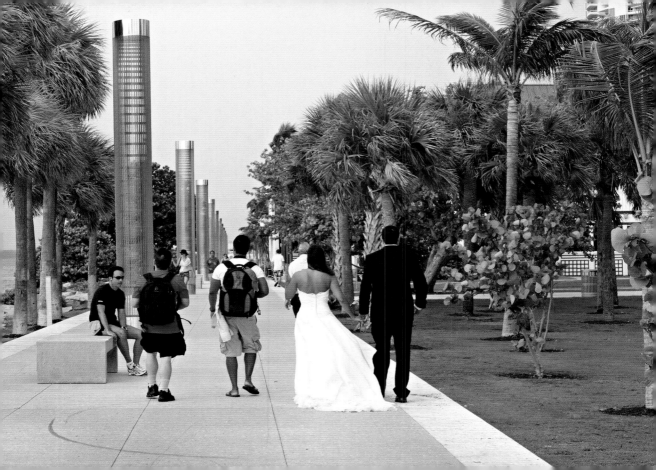

# THE KINGS OF SOUTH BEACH

These visionary, innovative and powerful personalities have each in their own right, made a significant contribution to the recognition, revival, preservation and popularity of The Art Deco District of Miami's South Beach. Firm friends, united by their common purpose, I had the privilege of meeting them and capturing this iconic and historically significant moment on Ocean Drive, June 2010.

Tony Goldman was born and raised in New York City and educated at Emerson College in Boston. He started renovating brownstone houses on the upper West Side in his early twenties and he is acknowledged as one of the pioneers of the district's famed resurgence. He was also the driving force behind the metamorphosis of New York City's SoHo neighborhood and the Wall Street Financial District as well as Philadelphia's City Center. In 1985, Goldman came across the gloomy urban decay of South Beach, scattered with run down and empty hotels. He immediately recognized the area's rich architectural and cultural significance as well as its investment potential and acquired 18 properties in the area by 1994. Today South Beach is one of America's premier destinations and for his significant role in its rejuvenation, Tony received the prestigious National Trust for Historic Preservation's Louise du Pont Crowninshield Award (2010).

David Wallack was born in New York in 1948 and his family moved to Miami Beach where he was raised. As a child David built sand castles on South Beach and as an adult he built a legacy on Ocean Drive. Graduating with honors from the University of Miami in 1972 and the University of Miami Law School in 1977, he went on to become the first President of the Ocean Drive Property Association in 1980. He served with distinction and advised the matriarch of the Art Deco District Preservation Movement, Barbara Capitman, through her travails, gaining popular and political recognition for the Art Deco movement in Miami Beach. Multi-talented and highly creative, Wallack put his personal stamp on South Beach. He infused ground-breaking vibrancy and quality care into The Eastern Sun, a personal care residence for the elderly. After operating The Eastern Sun for 12 years his interests began to merge with the newly formed MXE (mixed use entertainment) District in Miami Beach.

FROM LEFT: *Tony Goldman, David Wallack and Mark Soyka.*

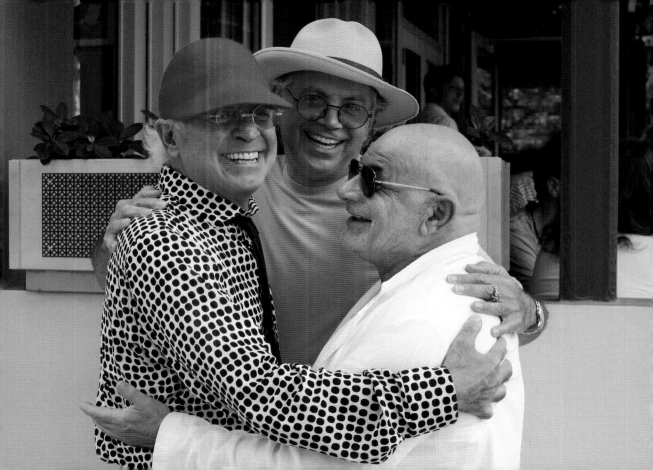

In 1990, David relocated the Eastern Sun residents, staff and two other facilities into a new Vision of Care for the Elderly. His dream to transform the Eastern Sun property into a commercial mixed-use of retail shops, restaurants, hotels and a nightclub called Mango's Tropical Cafe on Ocean Drive, was realized in 1991. His longtime fascination and association with artists and performers and his own songwriting and recording in the 1970's, inspired him to mastermind the rolling multi-level, entertainment spectacular that continues to draw capacity crowds day and night. Mango's, a Caribbean Island rock and reggae-themed bar, attracted culturally diverse employees and talented Latin musicians from Cuba, the Caribbean and Latin America as well as many patrons from those country's who came to settle in Miami. The venue evolved into a pulsating Latin vibe – a sensual extravaganza of Afro-Latin, Salsa, Merengue and Brazilian rhythms.

It is said that no one in the food and beverage industry has matched the contribution to the rebirth of South Beach as Mark Soyka, an affable 65 year old Israeli-born, high-risk-tolerant visionary who, with Jeffrey Davis, founded the original News Cafe on South Beach in 1988. Soyka was a major force in the defining period of the South Beach revival phenomenon. News Cafe opened as a quaint sidewalk venue with a newsstand and a bookstore, at the now prime corner location of 8th Street and Ocean Drive. Today it continues to be the "in" place to be seen for Miami's trendy set, with its chic relaxed environment of a traditional European Street café experience. National and international publications and a selection of classical and jazz music playing in the background are an enticing invitation to linger longer... Open all day every day, News Cafe has expanded over time to include a separate bar, full-service kitchen, additional sidewalk/courtyard seating and a custom-designed retail space. Nowadays it has been said that on a typical March Saturday, four to five thousand patrons are served over a 24 hour period! Soyka has recently signed a new 10 year lease with his long-standing friend and landlord Tony Goldman. To quote Mark "The News is a sort of Grand Central Station gathering spot for South Beach. Some come to change into their bathing suits, some to have coffee, some to have dinner. We keep it nice, we do the best we can and people seem to like it."

The Soyka Empire which includes other notable eatery icons such as Van Dyke (an anchor restaurant that helped the Lincoln Road revival), the Soyka Restaurant and Andiamo Pizza (which ignited the Biscayne corridor boom), demonstrate his astonishing instinct for location and potential ambience.

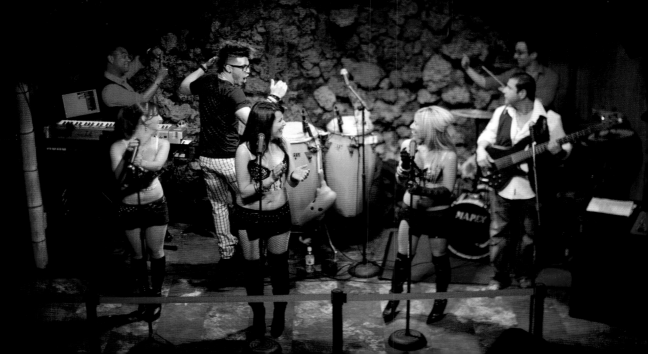

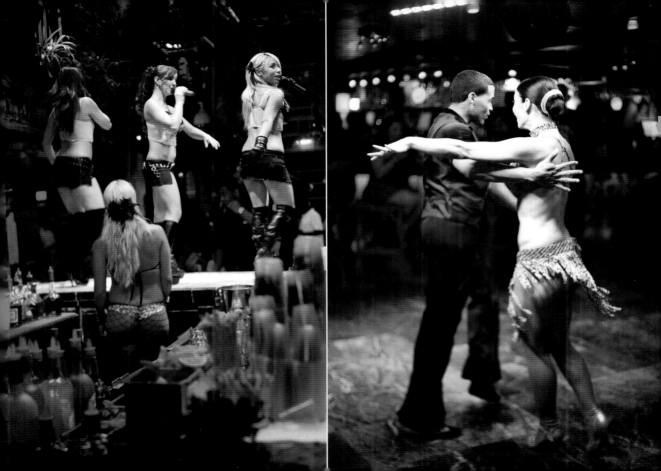

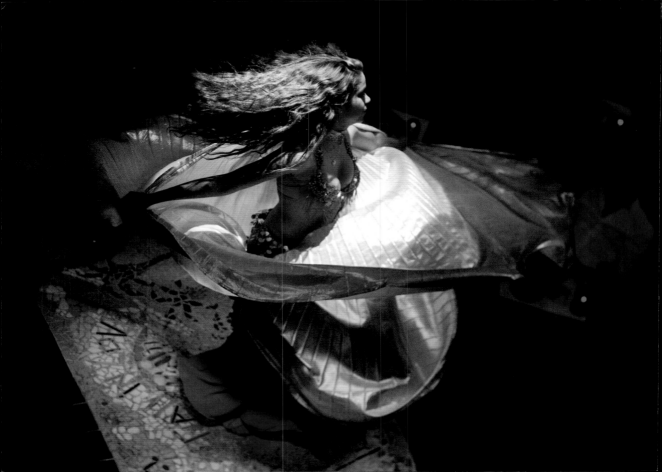

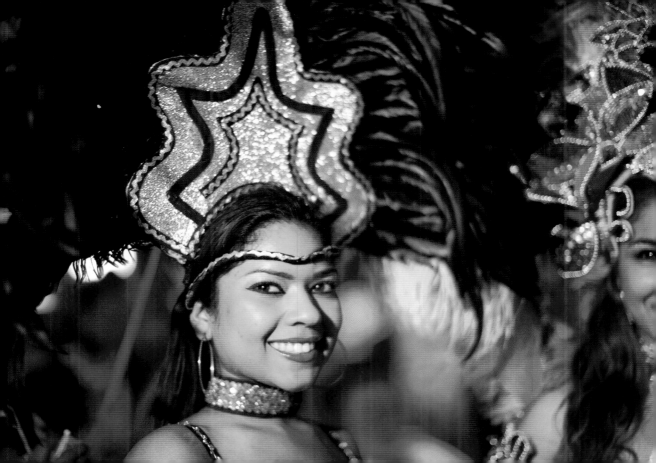

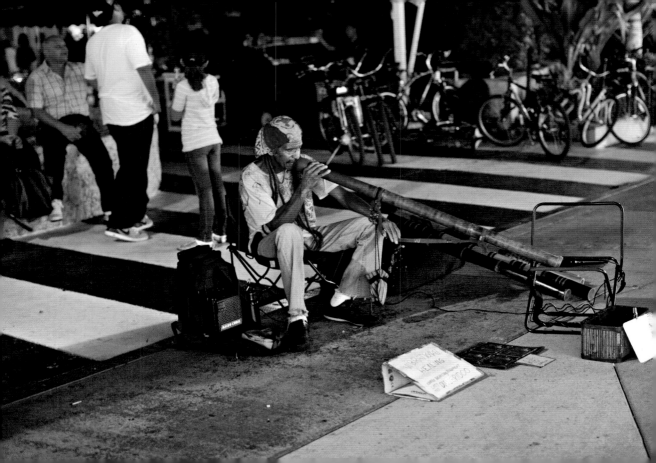

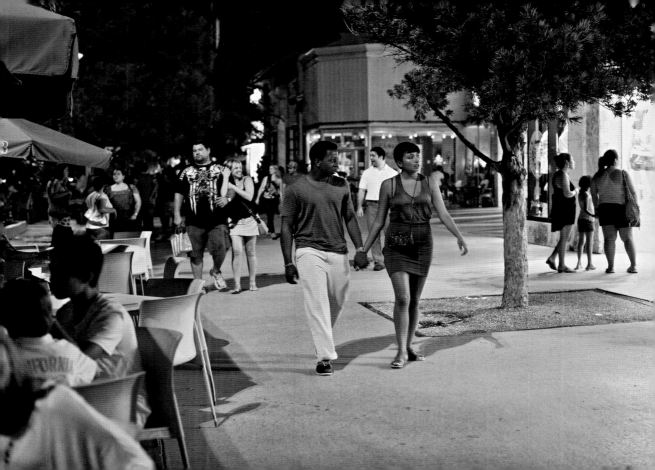

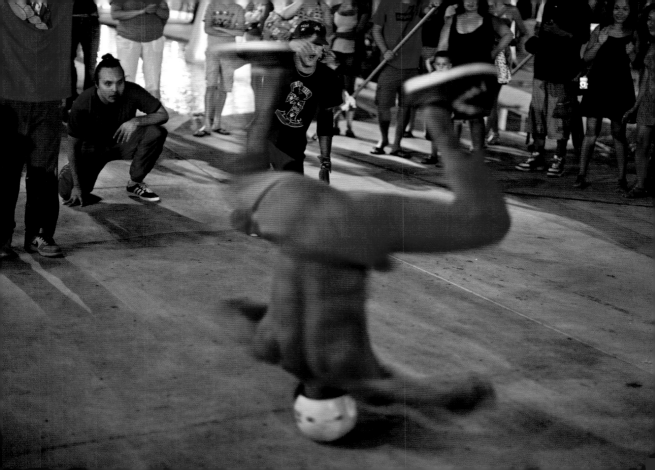

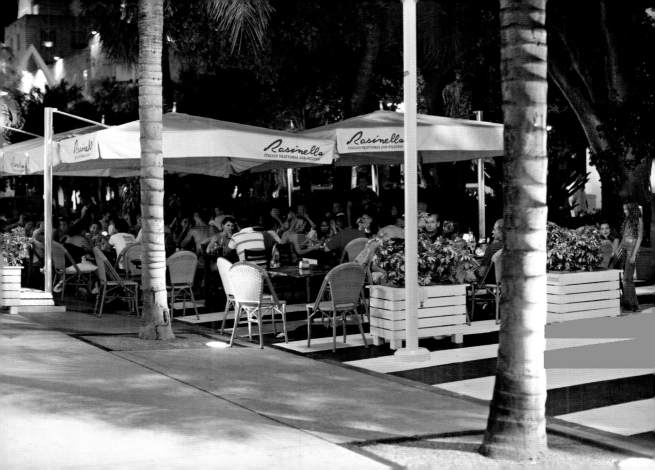

# FOGO DE CHÃO

Fogo de Chão in Miami is an unsurpassed culinary experience for "carnivorous" connoisseurs, adding to the impressive international flair of fine dining offered in South Beach. Diners are presented with an extraordinary prix fixe Brazilian banquet, where a parade of traditionally-dressed gaucho chefs (cowboys from the South American pampas) serve 15 delectable cuts of meat that have each been expertly fire roasted with age-old authenticity. Once selections have been made the meat is expertly carved with aplomb at the diners' table with a sharp carving knife. Equipped with a double-sided card, each diner has the choice to show the green side – resulting in another round of the enticing procedure, or the red side to admit a satisfying defeat.

Fogo de Chão is known to locals for their signature dish – the Picanha (pronounced Pea-CAN-ya), a prime cut of top sirloin with a distinctive house garlic seasoning. A gourmet salad and sides bar, an award-winning wine list, and a selection of decadent desserts like homemade papaya cream enhance the unforgettable experience.

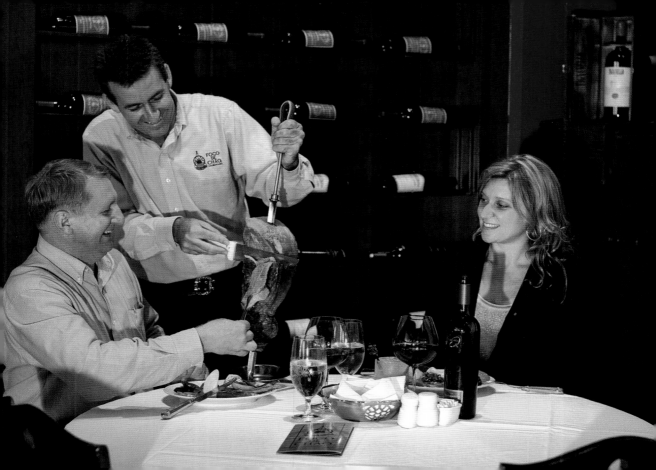

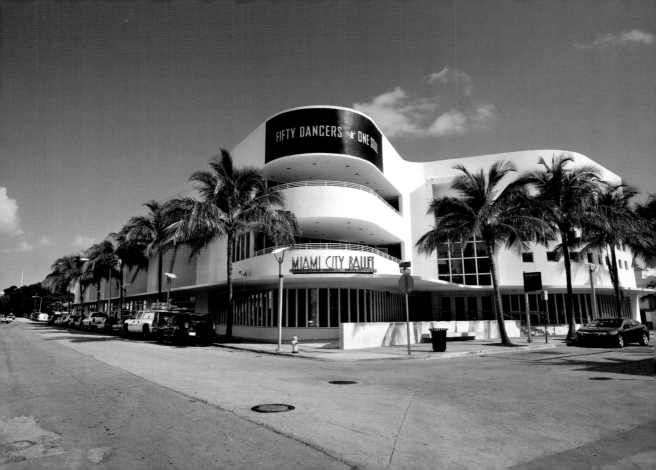

# MIAMI CITY BALLET

Founded in 1985 by Miami-Dade philanthropist Toby Lerner Ansin and American ballet superstar Edward Villella, the celebrated Miami City Ballet is today one of America's preeminent ballet companies. Under the artistic direction of Villella, the company has an active repertoire of 88 ballets and performs over 100 times annually, both locally and abroad. The company features ballets by American choreographers such as Jerome Robbins, Mark Morris, Trey McIntyre and Twyla Tharp, however the principle repertoire focuses on the work of Villella's mentor, George Balanchine.

In 2006 the Miami City Ballet became a resident company at The Adrienne Arsht Center for the Performing Arts, performing at the Ziff Ballet Opera House. The Ophelia & Juan Js. Roca Center (*left*) houses the Miami City Ballet headquarters and studios as well as the Miami City Ballet School, under the directorship of Villella's wife, Linda. Founded in 1993, the Miami City Ballet School is recognized as one of the top dance schools in America, preparing America's new up-and-coming dancers through its visionary leadership, forward-thinking curriculum and state-of-the-art facilities.

Classes are held at the Miami City Ballet's 63 000 square-foot studios and are attended by hundred's of gifted students throughout the year, 200 of which are selected to attend the school's prestigious Summer Intensive program.

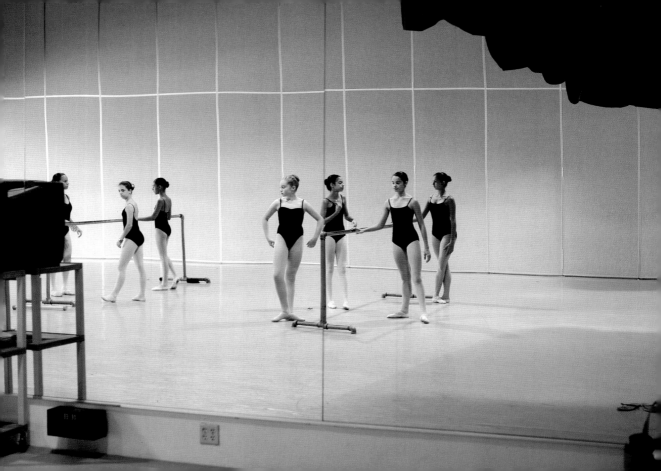

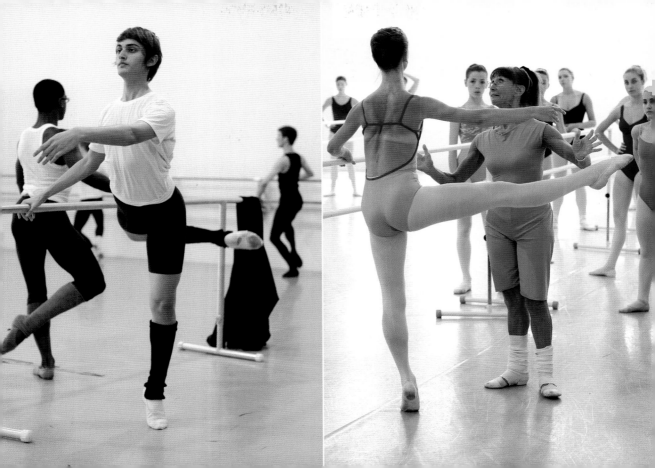

# NEW WORLD SYMPHONY

From its Miami Beach home base, the New World Symphony, America's celebrated orchestral academy, has redefined virtuosity in the 21st Century. With its dedication to the artistic, personal and professional development of outstanding instrumentalists, the New World Symphony prepares highly gifted graduates of distinguished music programs for leadership roles in orchestras and ensembles around the world.

The New World Symphony continues to flourish under the distinguished direction of Michael Tilson Thomas, conductor, composer, educator and pianist, who, with the late Ted Arison (an immigrant from Israel who founded Carnival Cruise Lines in 1974), founded the orchestral academy in 1987. Its impact and cultural contribution to Miami is profound, with some 60 performances annually, fifteen percent of them free to the public. These performances bring leading classical soloists, conductors and composers to Miami and also presents the New World Symphony to international audiences with performances abroad including venues such as New York's Carnegie Hall, London's Barbican Center and the Bastille Opera of Paris. The New World Symphony exposes this high level of artistry and creativity to more than 200 class rooms in 40 local schools each year in addition to providing free music lessons and mentoring promising young musicians.

The Lincoln Theatre (*see page 205*) home to the New World Symphony since 1989 provided a romance with its vintage Art Deco charm, however with the symphony's growing success the venue could no longer offer the physical capacity and acoustic requirements needed. Miami's South Beach has now been enriched with a new state-of-the-art theater designed by Frank Gehry, arguably the most respected and inventive architect alive today. The awe-inspiring New World Center is Gehry's first Florida commission and is a new landmark for American culture, attracting global attention from architecture, art, and music aficionados alike. The grand opening of the New World Symphony's new campus took place on 25th January 2011 with a stirring performance of Wagner's Flying Dutchman Overture, conducted by Michael Tilson Thomas, followed by Copland's majestic Third Symphony and the world premier of a newly composed work, by the British composer, conductor and pianist Thomas Adès. This Miami-driven initiative, not only takes the New World Symphony to new heights, but represents a significant contribution to the continuity and excellence of classical music in America.

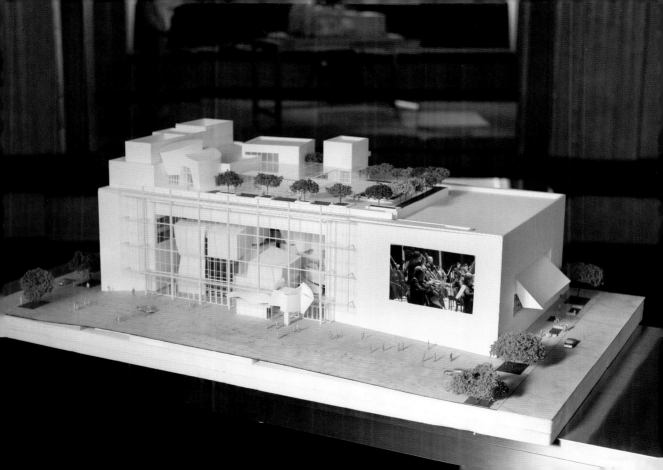

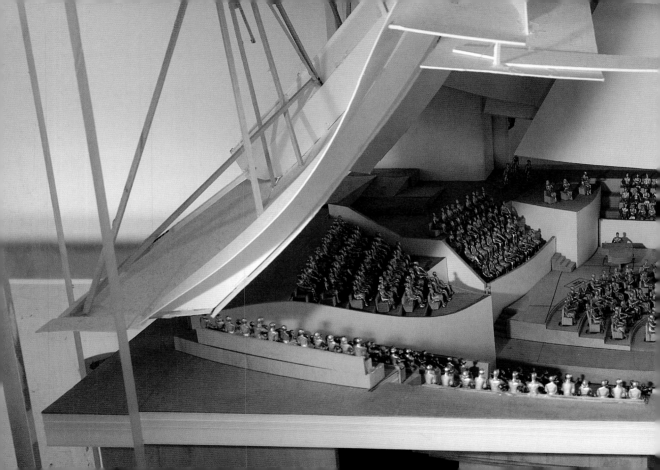

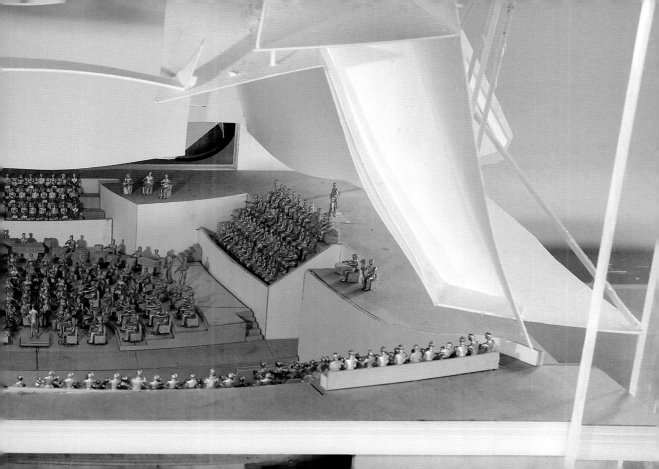

# JEWISH MUSEUM OF FLORIDA

The Museum is housed in two buildings that were formerly historic synagogues for the first congregation on Miami Beach. They were built south of Fifth Street, as this was the only area where Jews were allowed to live in the early days. One is an elegant 1936 Art Deco style synagogue with a copper dome and 80 stained-glass windows that was designed by Henry Hohauser, one of Miami Beach's most prominent architects. The original 1929 synagogue reflects the Depression era. The Jewish Museum of Florida, an internationally known cultural destination under the direction of Founding Executive Director and Chief Curator Marcia Jo Zerivitz, is a tour de force of memorabilia reflecting the history of extraordinary achievements made by Florida Jews since 1763, when they were first *allowed* to settle.

The museum evolved from a statewide grassroots project where hundreds of volunteers gathered material evidence of the Jewish experience in Florida. Originally a travelling exhibition (1990-94), it quickly became apparent that the fascinating collection would grow and deserved a permanent home. The museum opened in 1995 and now cares for more than 100,000 items

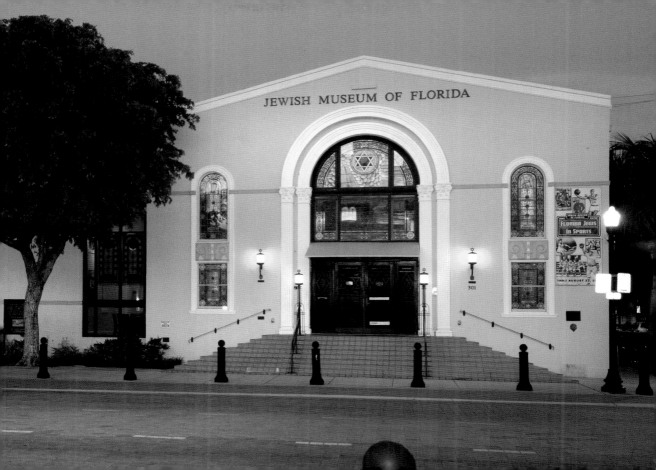

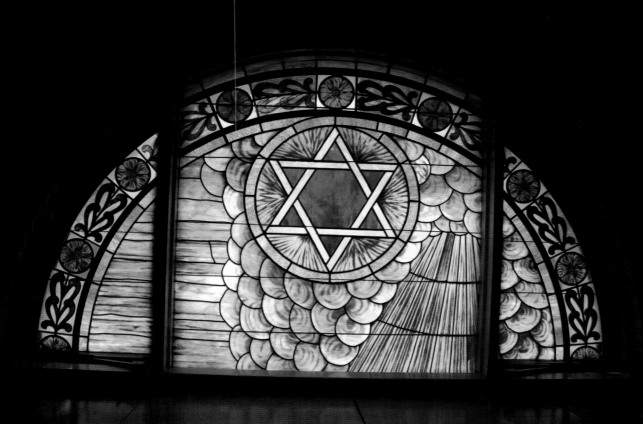

ranging from the Museum buildings (on the National Register of Historic Places) to a complete bound set of *The Jewish Floridian* (a statewide Jewish weekly that ran from 1928 to 1990).

The Jews of Florida played a major role in developing hotels, tourism, roads, bridges and cities, as well as the cattle, citrus and tobacco industries and became integral to the development of the State. The man who brought Florida into statehood in 1845 and built the first railroad across the state was David Levy Yulee, Florida's first U.S. Senator and the first person of Jewish ancestry to serve in Congress.

The museum's storyboard exhibits give a fascinating insight into diverse fields of endeavour and accomplishments including a Jewish Miss America, and many sports figures including owners of professional teams, a female billiards champion, tennis aces and the multi-Olympic medal swimming champions, Mark Spitz and Dara Torres.

Then there are boxing champions, baseball greats and equestrian show jumping champions, not to mention powerful politicians, lawyers, doctors, scientists, entertainers and artists. Even the notorious mobster, Meyer Lansky, who prayed at the synagogue, is acknowledged as a "generous contributor" as displayed on one of the sponsored stained glass windows.

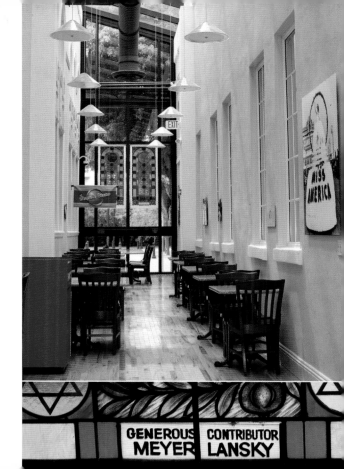

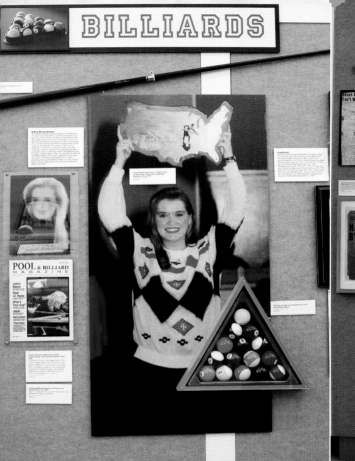

# BILLIARDS

# POOL & BILLIARD
MAGAZINE

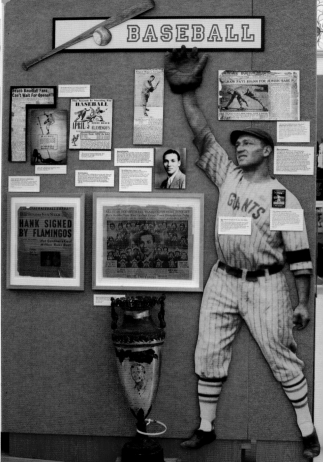

# BASEBALL

**Beach Baseball Fans Can't Wait For Opener**

BASEBALL
APRIL 5
FLAMINGO'S

MCGRAW PAYS $50,000 FOR JEWISH 'BABE RUTH'

**HANK SIGNED BY FLAMINGOS**

ALL-STAR BEND BALL TEAM

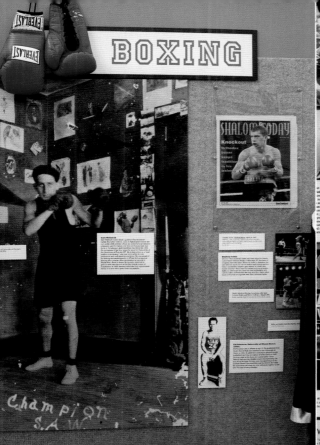

# BOXING

### SHALOM TODAY
**Knockout**
Orthodox
boxer
keeps
traditions
in his
training

**Sam Wolinsky**
Sam Wolinsky came from a poor Florida immigrant family. He rather fished, came to fight and honed his amateur and professional career...

**Sophie Gotlib**

**Ed Edelstein, University of Miami Boxer (1940s)**

Champion
S.A.W.

### THE SPIRIT

**#19, Will Eisner**
...reprint of one of Will Eisner's most popular...featured in a 2008 movie.

# WILL EISNER

"father of the graphic novel," was born in Brooklyn, New York. The son of Jewish immigrants, he experiences growing up in New York tenements...

... What a Magazine!" There, he met Jerry Iger, and in the 1900s, where they employed Jack Kirschberg, Bob...
...romantic *Four*, Lou Fine, creator of *Black Condor*, Bob...

Jewish Association of Florida, Miami Beach.

...eleon Drucker is a granddaughter of a Polish to Cuba immigrants who settled in Florida in the 1920s. She has... major force in developing the cultural climate of South ... since 1961. Judy started her musical career at the age ...and developed into an opera singer. As founder and ...ent of the Concert Association of Florida until 2002, Judy ...perhaps best known for bringing Pavarotti to the ...produced concerts of world-class symphonies, ...opera stars and dance companies, developing the ...ation into the region's largest presenter of touring ...al artists. Here she is shown in 1968 with David Ewen in ...ion for "An Evening with Gershwin."

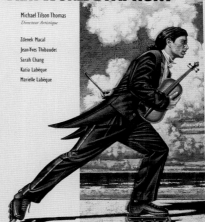

## The Arts

Jews in Florida have contributed greatly to the development of the cultural arts throughout the state. They earned their living through the years in the arts, started many of the museums, ballet companies, symphonies, theaters and performing arts centers, as well as giving largely for the continuing financial support.

**Miami City Ballet Founder Toby Lerner Ansin (center) with Miami City Ballet dancers, 1991.**
Toby Ansin dreamed as a child of being a ballerina, realized she did not have the talent and went on create the Miami City Ballet. In 1985, after a conversation with Edward Villella to hear his 10-year plan and six friends joining her in contributing $1,000, she decided this is what South Florida needed to round out its cultural life. Today the Miami City Ballet is one of the nation's major dance companies and performs globally.

**Movie Theaters**
The first WOMETCO (Wolfson...
opened in Miami at Third Street...
In 1949, the theater was construc...
TV station, WTVJ. Mitchell Wo...
merchants Louis and Rosa Wo...
mayor of Miami Beach (1943)...
Century Fox moving picture...
married Louis Wolfson. Broth...
teamed up to form WOMETC...
other theaters, radio and TV...
and other industries, which...
capital.

**"Look...**
Louis M...
1810, th...
Jackson...
in...

 JAY M...

Jay Moran, former Miami Beach resident...

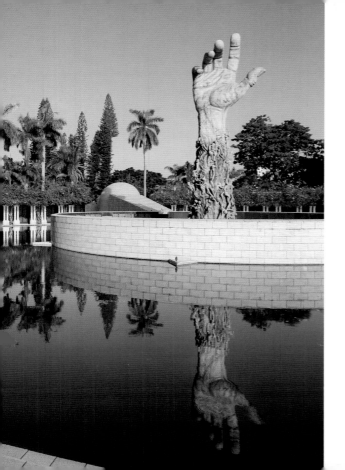

# HOLOCAUST MEMORIAL

A gigantic bold bronze arm with a green patina, 42 feet high, soars powerfully skywards. It depicts a large indelible dehumanizing number, tattooed on the underside of its forearm. Numerous emaciated bodies seem to scream in disquieting, agonizing despair, their sheer terror palpable as they appear to leap from the arm in suspended animation.

The stillness of the water, reflecting the blue Miami sky in the circular pool surrounding the center piece and the black granite contrasting with the luminous Jerusalem stone appears to heighten their anguish with its stark juxtaposition.

In memoriam to the genocide of 6 million Jewish men, women and children under the German Nazi regime during the Second World War, this moving sculpture, at Meridian Avenue and Dade Boulevard, is a poignant world-renowned masterpiece. It is the work of architect and sculpture Kenneth Treister and was cast by hand in Mexico by Fundicion Artistica taking more than 4 years to build.

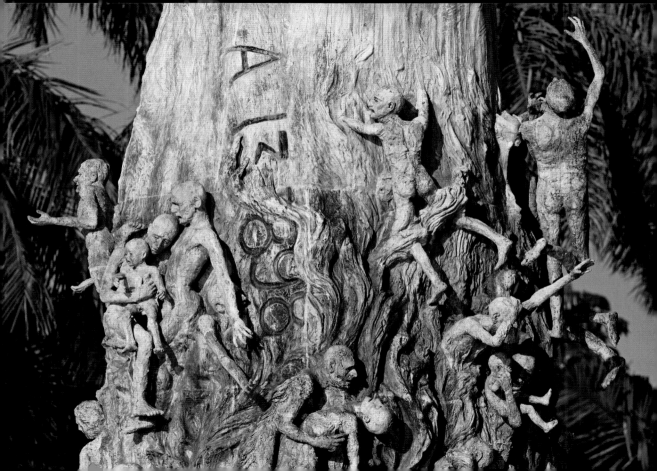

# THE JEWISH SEAT OF LEARNING

Florida has a Jewish community some 750 000 strong, the third largest in the United States of America.

Spiritual leader of the Chabad-Lubavitch movement, Rabbi Abraham Korf (*overleaf right)* was once a student of a secret Jewish school in the Soviet Union before moving to America. He relocated to Miami from the tight-knit Hasidic community of the Crown Heights section of Brooklyn, New York in 1960 and headed to Miami Beach on behalf of the venerated Rebbe Menachem Schneerson. Rabbi and Mrs. Korf engaged with the South Florida community in transformation. Jewish immigrants from Latin America and the Caribbean joined the pre-1940s communities mainly from the north ocean port of Jacksonville and retirees from out of state to form a Jewish hub.

The Chabad-Lubavitch Headquarters of Florida have a proud record of spiritual growth and achievement spanning half a century. Rabbi and Rebbitsen (his wife) as spiritual leaders of the Hamedrash Levi Yitzchok, Miami Beach, started out teaching just 6 children. Renowned for their high spiritual, moral and academic standards, they run a preschool, elementary school, Bus Chana High School for Girls, and a yeshiva (rabbinical college). The complex serves approximately 800 students.

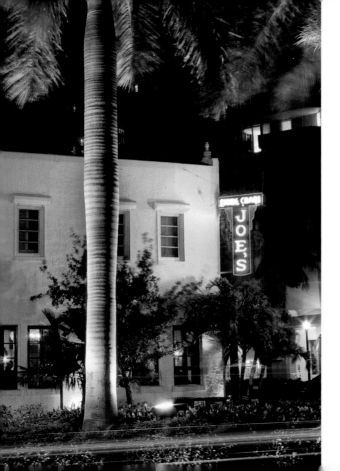

# JOE'S STONE CRAB

Four generations ago in 1920, Joe and Jenny Weiss opened a fish house in the days when South Beach was only accessible by Ferry and before it had gained international stature. Immediately popular with locals and visitors alike, eating at Joe's was considered "one of the things to do" in South Beach. The restaurant is truly a South Beach icon, renowned the world over, through their enterprise, hard work and happenstance. One day George Howard Parker, an eminent Harvard professor of ichthyology who was conducting research in the area, popped in for breakfast and struck up a conversation with Joe concerning his research into *Menippe mercenaria* (Stone Crabs) and their possible culinary potential.

"Nobody will eat them!" said Joe. That very lunchtime Professor Parker returned with a bag of live Stone Crabs and a debate on how one might prepare them ensued. Joe put them in boiling water cracked open their claws with a wooden mallet and a legend was born. Frequented by U.S. Presidents and celebrity patrons from far and wide, Joe's Stone Crab is renowned for its exceptional cuisine and impeccable service by long-serving staff members considered to be and treated like extended family members.

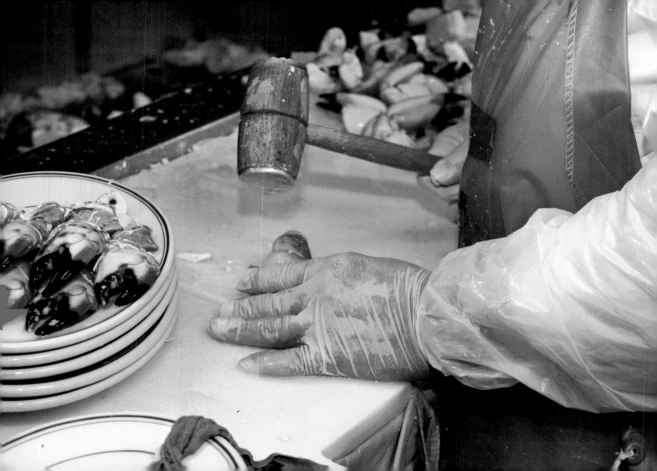

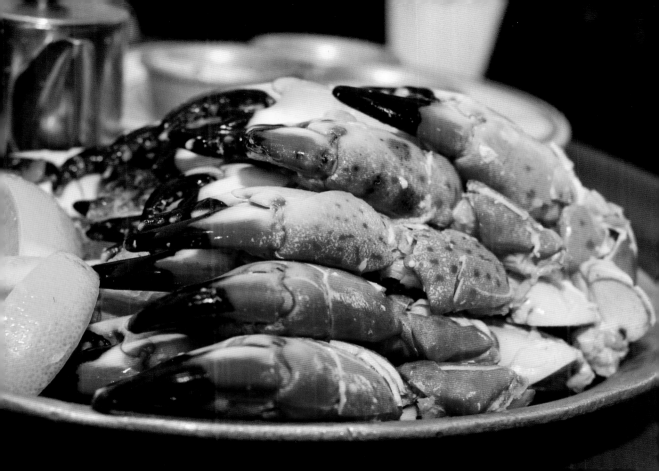

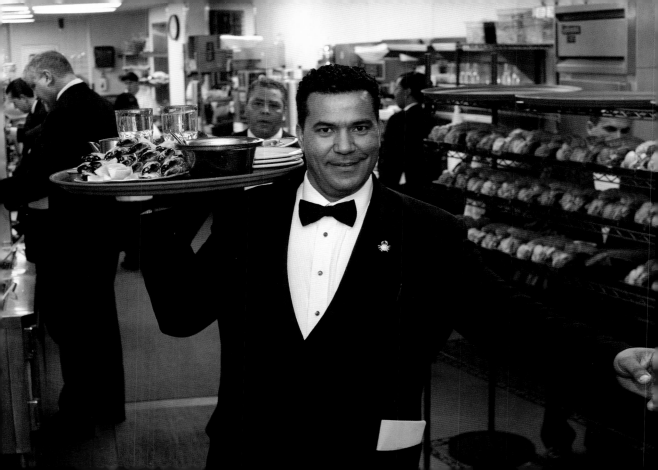

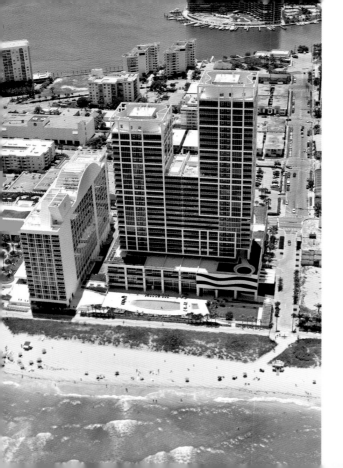

# CANYON RANCH MIAMI BEACH

The Canyon Ranch story began in 1978, when 49 year old Mel Zuckerman, overweight, stressed and unhealthy, resolved to change his lifestyle. After trying several of the available methods and experiencing initial setbacks, Mel discovered the right healthy lifestyle balance and achieved a life-enhancing paradigm shift. Weight loss, fitness and balance left Mel elated, invigorated and fascinated by the benefits and the overall feelings of well being. He and his wife Enid felt an overwhelming desire to help others to achieve the same results, resulting in opening of Canyon Ranch in Tucson, Arizona. The rest, as they say, is history – today Canyon Ranch is one of the most respected and admired destination resort spas in the world.

Canyon Ranch Hotel and Spa in Miami Beach is a landmark resort continuing the Canyon Ranch spirit in true Miami style. Property developers and converts to the Canyon Ranch Lifestyle, Phillip Wolman and Eric Sheppard convinced Zuckerman to join them in restoring, converting and expanding the historic Carillon Hotel into an exciting new hybrid expression of the Ranch: a healthy living condominium community

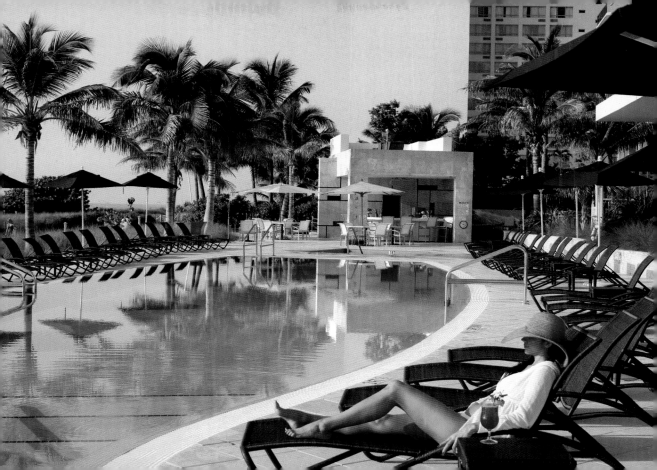

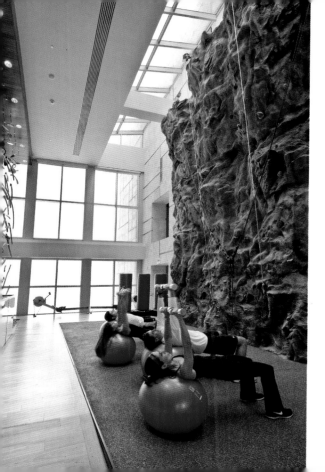

and à la carte hotel wrapped around a state-of-the-art Wellness Spa.

In its heyday, the Carillon was the epitome of 1950's Miami modern style and its painstaking renovation was undertaken with a commitment to preserving its history, restoring this elegant building to more than its former glory.

The spectacular décor, by renowned American architect and designer, David Rockwell, captures the energizing, harmonious essence of Canyon Ranch, introducing an array of natural materials from shell and stone to the lavish use of wood, all creating the feeling of bringing the natural world indoors while fully embracing the original elegance of the Carillon.

The facilities available to guests are all-encompassing from fitness classes, specialized therapies, life management courses and rock climbing to beauty salons, fine dining and of course its world famous wellness spa. This one-of-a-kind boutique hotel is an example of the extraordinary diversity of lifestyles and the myriad possibilities of choice Miami has to offer the visitor.

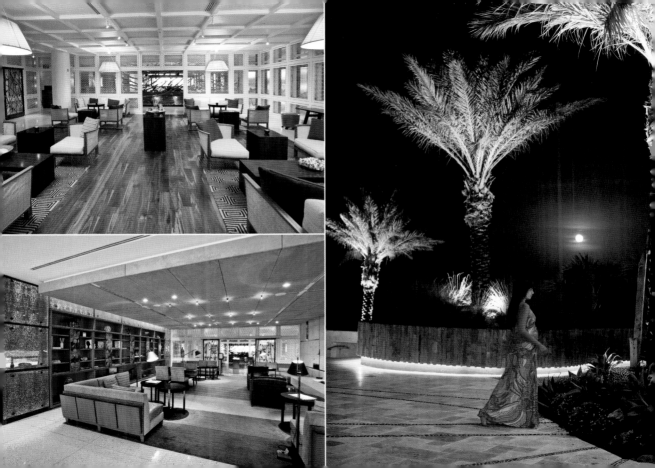

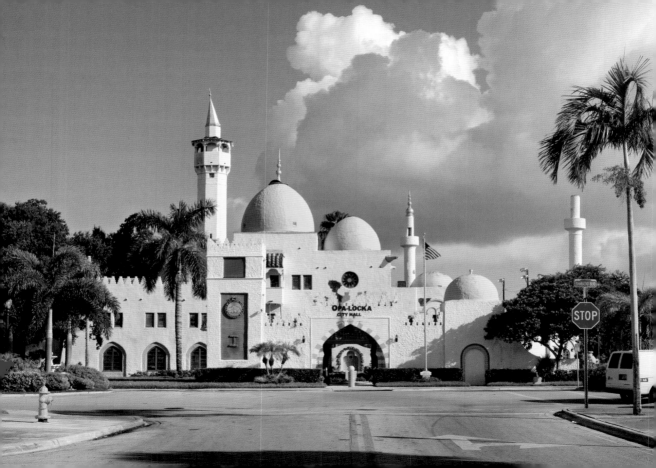

# OPA-LOCKA CITY HALL

This extraordinary Moorish fantasy, the Opa-locka City Hall, located in northeastern Miami-Dade County, is but one of this cities themed collection of Moorish Revival architecture. Opa-locka was founded in 1926 by the aviation pioneer, Glenn Curtiss who introduced the Arabian Nights theme, including street names such as Ali Baba Avenue and Sesame Street. The Miami Hurricane later that year caused severe damage to the area and brought the land boom to an abrupt halt. Several Moorish Revival buildings however have survived and are believed to be the largest collection in the Western Hemisphere.

Curtiss originally named the district Opa-tisha-woka-locka, the Native American name for the area meaning, "the high land north of the little river on which there is a camping place."

The famous German Zeppelin, a self propelled cigar-shaped airship designed by Ferdinand Graf (count) von Zeppelin (1838-1917), began its transatlantic flight service in 1928, making NAS Miami which later became Opa-locka Airport, a regular stop on its Germany-Brazil-United States-Germany scheduled route. After completing 590 trips, the Hindenburg Disaster halted operations.

The Miami Municipal Airport, just south of the city, was where the legendary U.S. aviator Amelia Earhart (1897-1939) launched her historic first trip around the world. She was the first woman to fly solo across the Atlantic Ocean in 1932.

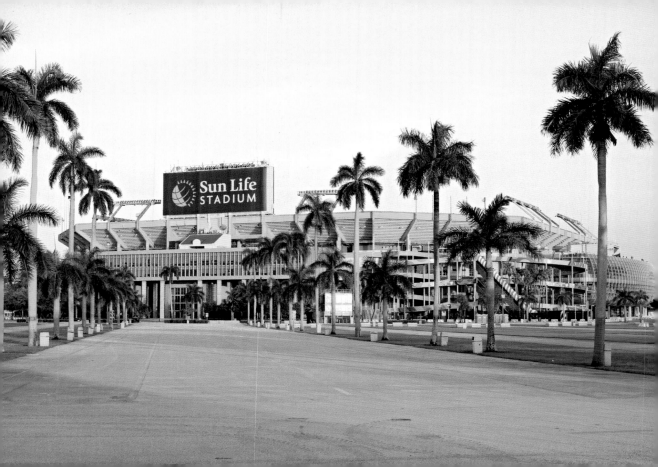

# SUN LIFE STADIUM

The grand multi-purpose Sun Life Stadium, at Dan Marino Blvd in Miami Gardens is a focal point of American sporting culture. It is the only stadium that houses teams from the N.F.L. (Miami Dolphins), M.L.B. (Florida Marlins) and an NCAA Division I College Football team (University of Miami Hurricanes). While the stadium has gone through no less than six name changes (it was originally named after Joe Robbie, the then-owner of the Miami Dolphins) the events held there are consistently sensational. Sporting events hosted at the stadium include Super Bowls, World Series and BCS National Championship games, and a wide range of other events take place too – from Rock Concerts to Monster Truck shows to religious gatherings, most notably a visit by Pope John Paul II.

<div align="center">

FLORIDA MARLINS vs ST. LOUIS CARDINALS
SATURDAY 7th AUGUST 2010

</div>

RIGHT: *Marlins Logan Morrison in action.*

OVERLEAF LEFT: *Marlins ace pitcher Josh Johnson.*

2ND OVERLEAF: *The Marlins moment of triumph and spontaneous jubilation as they win the game 5-4. The euphoric crowd erupts, spectacular firework displays fill the night sky and entertainers add to the carnival atmosphere.*

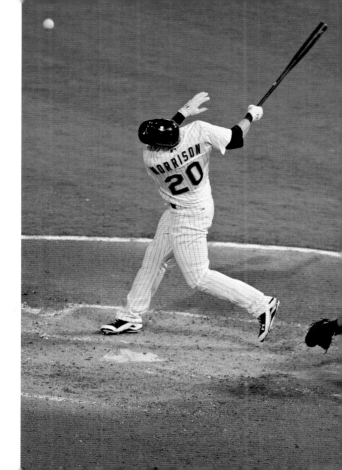

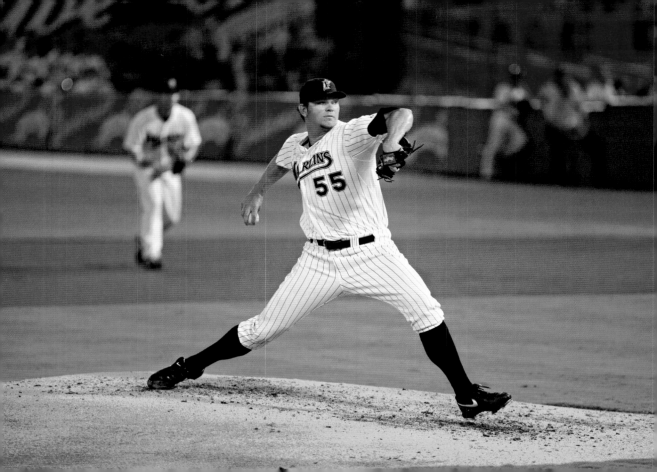

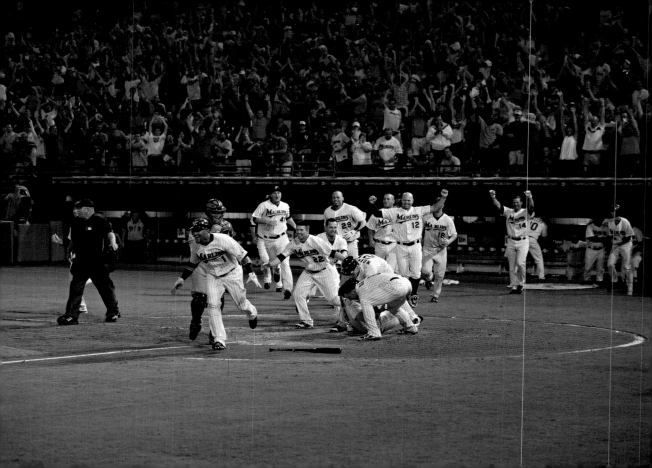

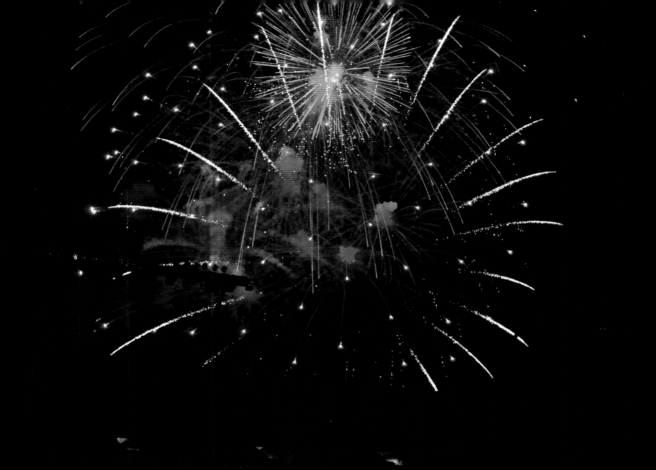

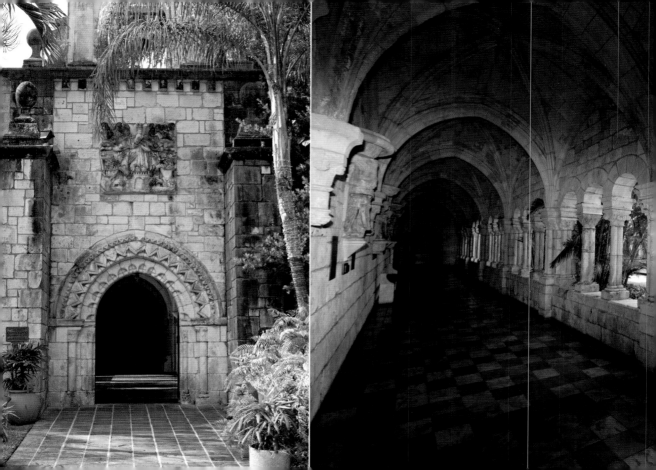

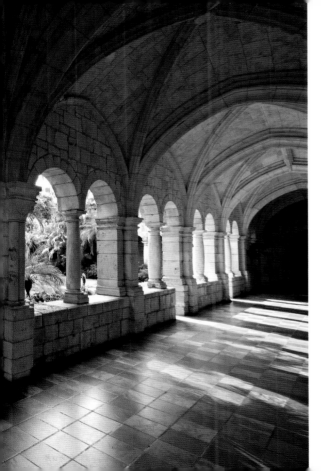

# ANCIENT SPANISH MONASTERY

In 1925 newspaper tycoon William Randolph Hearst bought the cloisters of a Spanish Monastery built in Segovia, Spain between 1133 and 1141. He had its 35 000 stone masonry components carefully dismantled, sequenced for reconstruction, crated and shipped to America. Due to an outbreak of foot-and-mouth disease at the time, stringent measures were in place at America's ports and on arrival in New York, the crates were opened for inspection of the straw packing. The inspectors did not realize the significance of the order in which the stones were packaged for re-construction and they were repacked out of sequence. These crates consequently lay in storage in New York until 1952. A mammoth and costly task proceeded in an attempt to reconstruct what became a giant masonry "jigsaw puzzle." Allen Carswell who built the Cloisters in New York completed the task in 1952-1953.

Its sun-dappled Gothic arches, picturesque courtyard with a statue of Alphonso VII (patron of the monastery), a chapel still used for worship and a chapterhouse as well as a well manicured quiet garden, is truly a "little bit of mediaeval Spain in North Miami Beach."

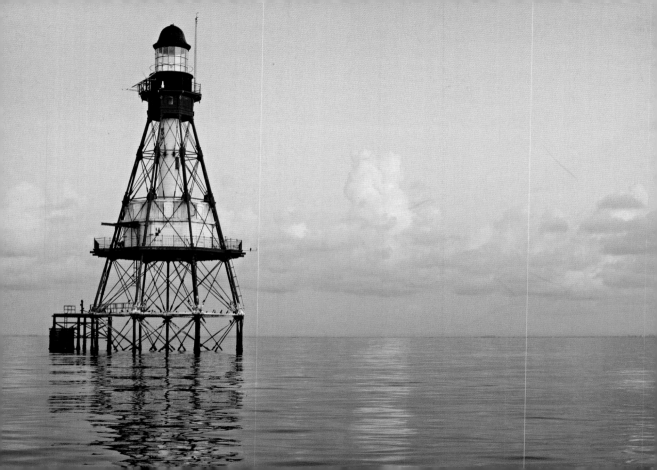

# LIGHTHOUSES IN MIAMI & THE NEARBY COAST

The Cape Florida lighthouse was built in 1825 (*right and overleaf*) at the south end of Key Biscayne in Miami-Dade County, Florida. It operated until 1878, when it was replaced with the Fowey Rocks lighthouse (*left*), seven miles southeast off Cape Florida on Key Biscayne. The Fowey Rocks lighthouse was named after the Royal Navy frigate HMS Fowey, wrecked on a different reef to the south in 1748.

Cape Florida lighthouse is steeped in history. In 1835 a major hurricane struck the island causing considerable damage. This was followed by an attack on the lighthouse by Seminole Indians, during the Second Seminole War in 1836 and in 1861 confederate sympathizers destroyed the lighthouse lamp and lens. From 1888-1893 the lighthouse was leased to the Biscayne Bay Yacht Club as its headquarters by the U.S. Treasury for a nominal $1 per annum. After the lease expired, it relocated to Coconut Grove where it still exists today.

In 1898 the lighthouse was briefly made into U.S signal station no.4 in response to the tension with Spain over Cuba that resulted in the Spanish-American War.

*cont. 2nd overleaf*

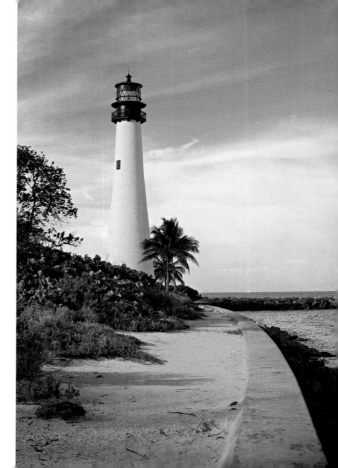

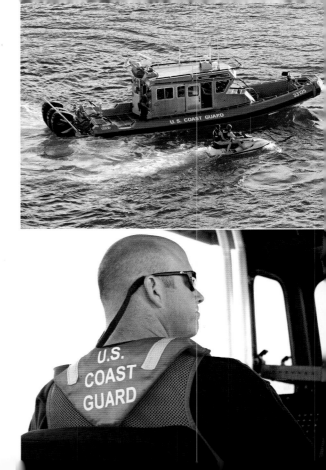

*cont. from p145*

The lighthouse was once sold to James Deering, the International Harvester magnate and owner of Villa Vizcaya in Miami, much to the consternation of government officials but they eventually conceded to the validity of his purchase from Waters Davis in 1913. The lighthouse was bought by the State of Florida in 1966 and became part of the Bill Baggs Cape Florida State Park. In 1978 the Coast Guard installed an automated light, as an aid to navigation, to help locate the Florida Channel at night.

RIGHT: *The Hillsboro Inlet lighthouse is located on the north side of the Hillsboro Inlet, in Hillsboro Beach, Florida. First lit in 1907 and automated in 1974 to aid navigation, it is a very powerful light placed 136 feet (41m) above sea level with a beam that can be seen 28 miles (45km) away.*

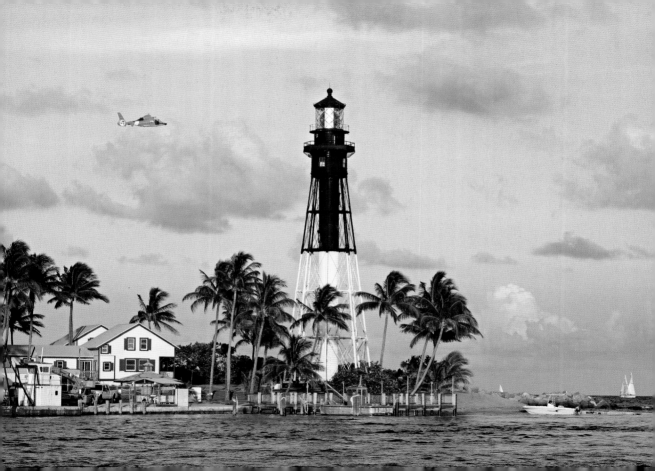

# STILTSVILLE

*As if afloat,*
*As if adrift,*
*As if they would never shift,*
*The chic shacks of Stiltsville*

Mid-ocean, south of Biscayne Bay, bygone-era wooden shacks on stilts stand steadfastly, despite the fury of hurricane Andrew in 1992 and the ravishes of the tide, the wind and the weather. It is generally believed that the first of these wood stilt houses was built in the early 1930s, although some historians believe that there were already several in existence as early as 1929. Collectively this unusual group of houses has become known as "Stiltsville" – an enduring part of local Floridian folklore.

If the Stiltsville houses could speak, all would have fascinating tales to tell; like the legendary "Crawfish" Eddie Walker, a local fisherman who was known for his *chilau*, a delectable crawfish chowder which he sold from his shack along with cold beers and fresh bait to seafaring men. Then there was the Quarterdeck Club which opened in 1940 with membership by invitation-only attracting celebrities of the day.

In 1962 The Bikini Club opened offering free drinks to bikini clad women and a sun deck for nude bathing for a mere $1 membership fee.

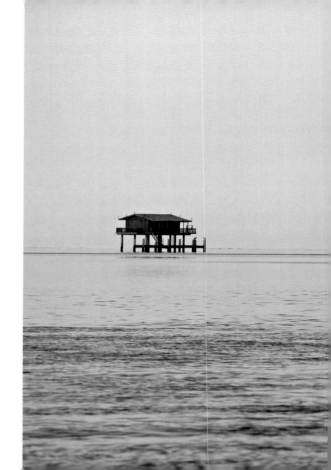

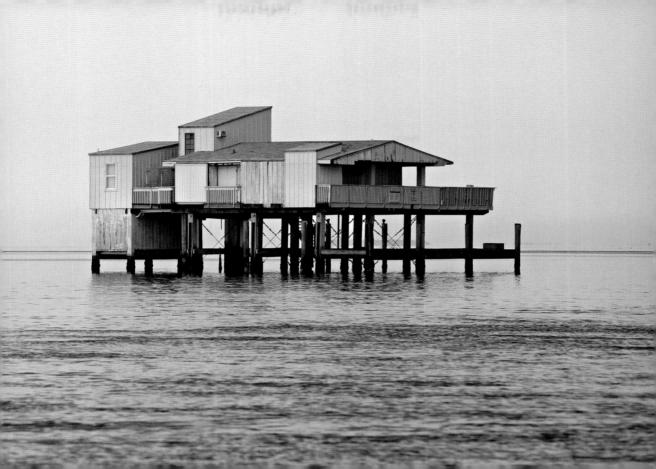

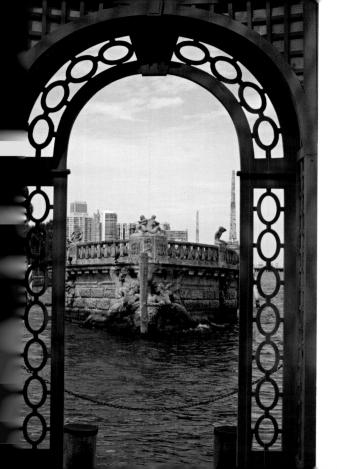

# VIZCAYA MUSEUM AND GARDENS

Vizcaya, one of Miami's distinctive landmarks and popular tourist attractions, was the winter residence of James Deering of the Deering Mc Cormack-International Harvester fortune. The name Vizcaya is taken from the Northern Province of Vizcaya in Spain, located in the Basque region along the east Atlantic's Biscayne Bay. Deering's home Vizcaya, fronts the West Atlantic's Biscayne Bay.

The estate, situated in an expansive Coconut Grove landscape, is in a waterside setting reminiscent of Venice. Miami's skyline lays juxtaposed in the distance. The grand early 20th Century home is an eclectic fusion of architectural styles: Mediterranean Revival with Baroque, Italian Renaissance and Italian Renaissance Revival.

The design director Paul Chalfin, a former art curator, interior designer and painter was the principle visionary and advisor to James Deering and was the tour de force in creating the Vizcaya dream. The villa was constructed between 1914 and 1919 and work on the gardens and the village continued unto 1923. Deerling spent his winters at Vizcaya from 1919 until his death in 1925.

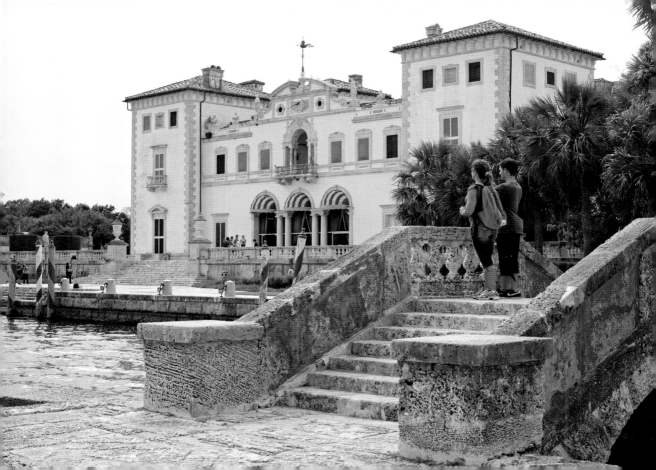

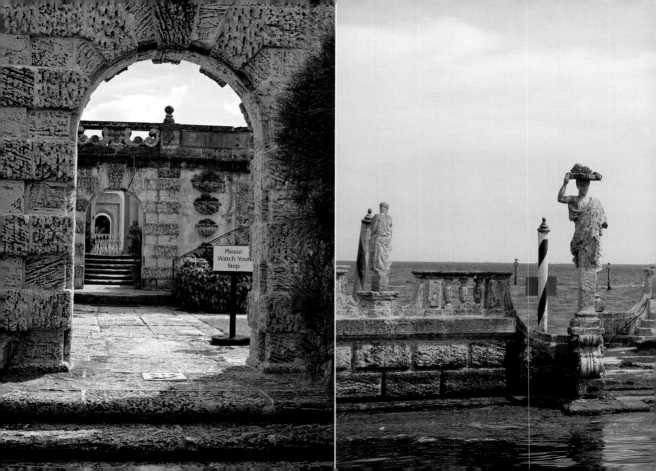

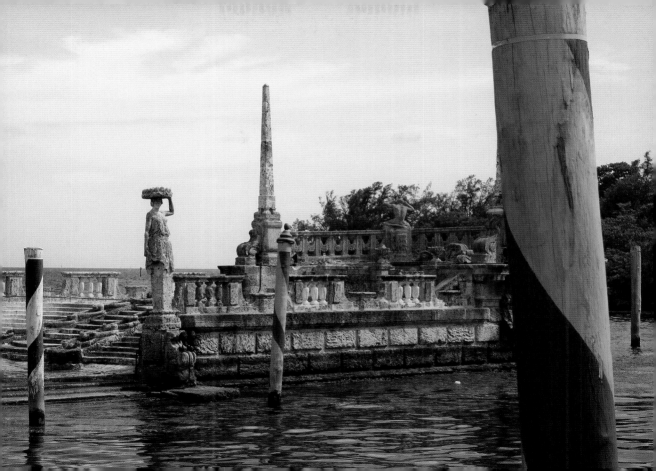

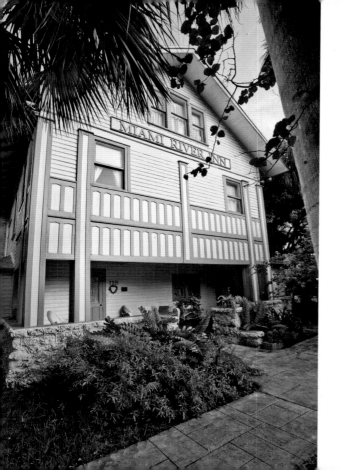

# MIAMI RIVER INN

This historic riverside inn is the oldest of its genre south of St. Augustine. Built between 1906-1910, this delightful example of an early riverside structure is today run as a popular Bed and Breakfast. Exuding old world charm and comfort, the Miami River Inn resonates with guests providing a sense of Miami's pioneering past. Pale yellow with green detailing, the group of vernacular-framed bungalows of coral rock, wooden shingles and masonry is tastefully furnished in the style of the period. The Mission-style hostelry is set among shady tropical trees, a large swimming pool and a verdant garden, complete with a manicured croquet green.

The Riverside neighborhood on the South side of the Miami River was laid out in 1896 by Mary Brickell and Henry Flagler. In 1905 a subdivision was developed by the Tatum brothers, who built a bridge over the Miami River at 12th Street (now Flagler Street) to connect the business district. A trolley once ran from the riverside over the bridge to downtown Miami. In 1987 the Miami River Inn complex, then known as the South River Drive Historic District was placed on the National Register of Historic Sites.

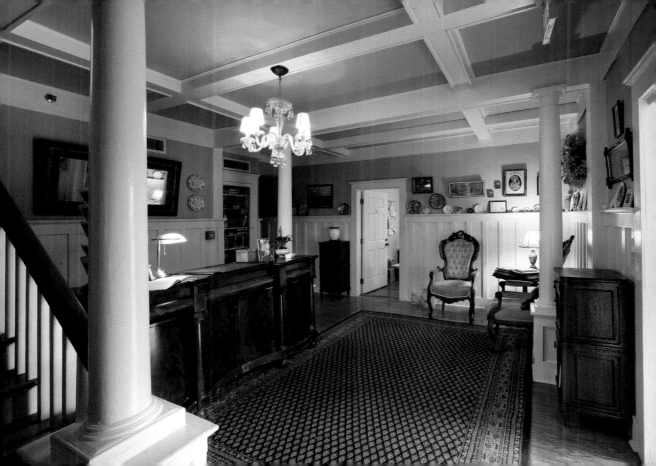

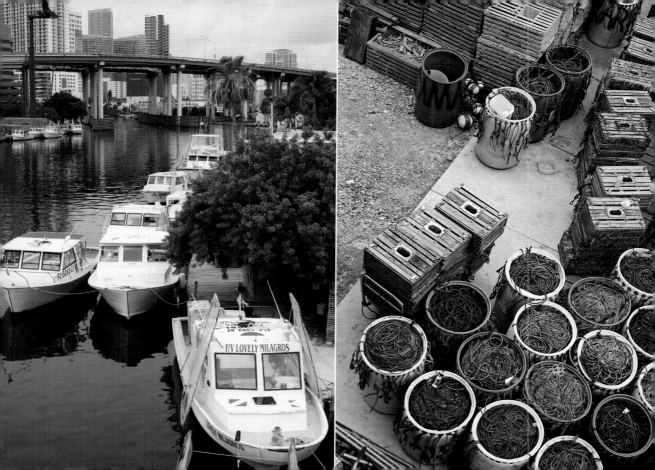

# MIAMI METRO ZOO

One of the world's great zoos and the only zoo in the continental United States located in a subtropical climate, the vast Miami Metro Zoo is an experience not to be missed. More than 900 wild animals are exhibited in expansive cage-less settings, from which many can be seen at an astonishingly close range in complete safety.

The Miami zoo is spread over some 740 acres that is inhabited by over 2000 animals, representing over 500 species. Many of the world's endangered species are represented here, such as the magnificent Bengal tiger, which can be seen in an authentic Asian jungle setting. With over 70 different bird species one can also see the quintessential, lithe and lovely pink flamingos that have inspired so many artists, especially during the Miami's Art Deco period.

The Miami Metro Zoo's breeding programs have received widespread recognition and many prestigious awards, ranging from several First Breeding Certificates to the Edward H. Bean Award, the zoological profession's highest honor.

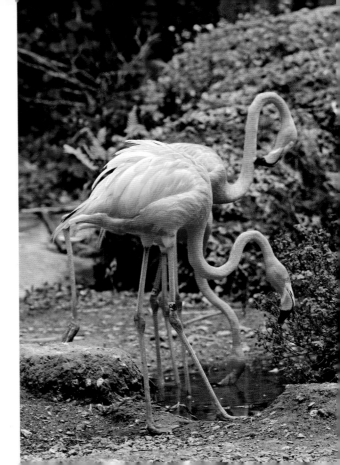

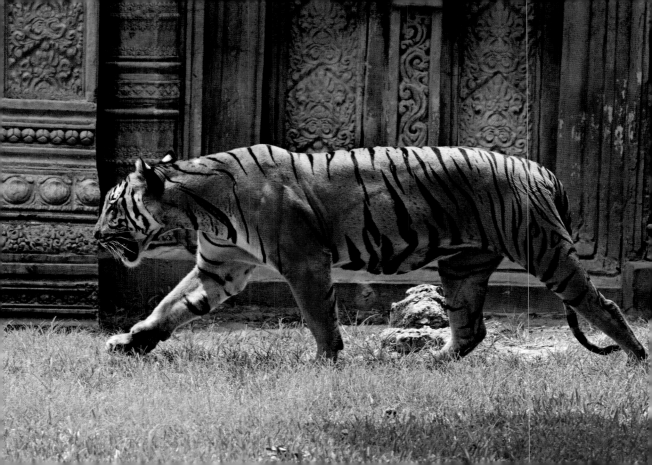

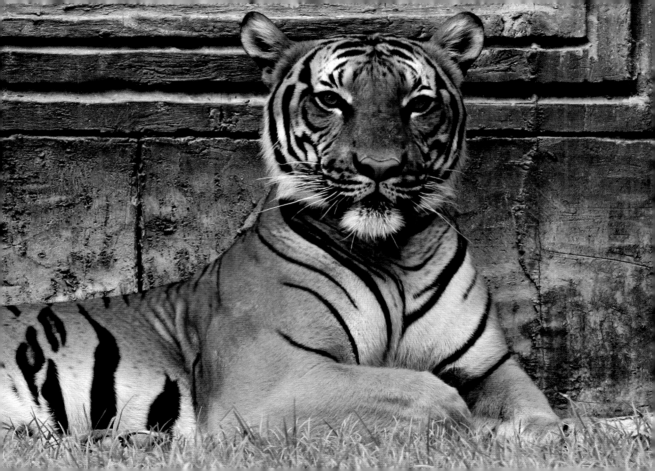

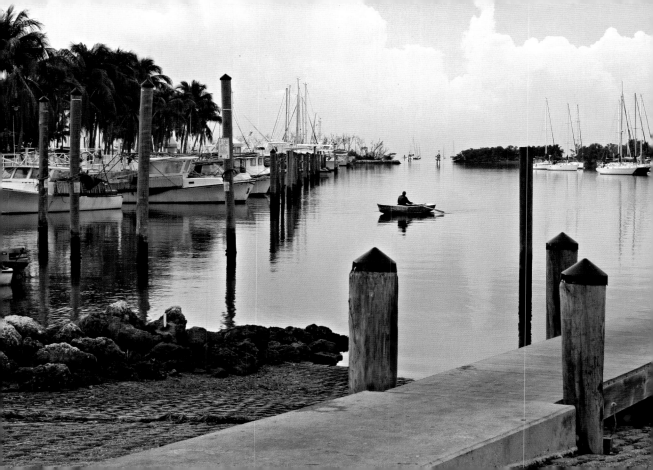

# COCONUT GROVE

The first settlers of Coconut Grove, a verdant, tropical paradise, were Bahamian sailors in the 1800s. This is Miami's oldest community. Another influx of people came with the building and commissioning of the Cape Florida Lighthouse in 1825. The post office was established in 1873 and around this time further groups arrived, including Americans from the Northeastern US, as well as British and Caucasian Bahamian immigrants.

Coconut Grove's first hotel, The Peacock Inn, was built by Bahamian builders in 1882 for Charles and Isabella Peacock, immigrant meat wholesalers from London. The hotel, by the sparkling blue waters of Biscayne Bay, became a popular social gathering place for the nascent village community. The socializing grew and never stopped to this very day!

As night falls, Coconut Grove "grooves", transforming into a people-watching kaleidoscope, as young professionals and students from the nearby University of Miami and Florida University, hit town. Bistros, food courts, clubs, bars and restaurants to satisfy the most fastidious connoisseurs leaves one spoilt for choice. The huge open-air shopping malls of Coco Walk and Streets of Mayfair continuously buzz.

The renowned Coconut Grove Arts Festival is an annual highlight of Miami's cultural calendar. Each year, some 150 000 visitors attend the festival to be inspired and buy artworks by the world's leading artists and craftsmen. Other Coconut Grove events include the King Mango Strut (which began as a parody of the Orange Bowl Parade) and the traditional Bahamian Goombay Festival – a week-long carnival celebration of rich cultural heritage during mid-June where revelers dress in vibrant colors and gyrate to the exciting rhythms of Goombay drums and whistles.

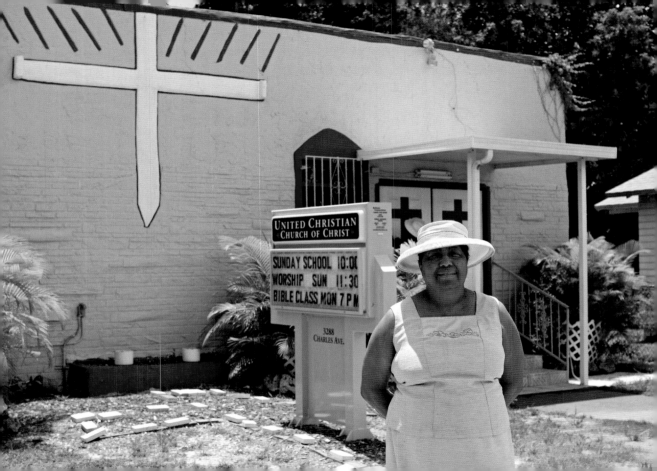

UNITED CHRISTIAN
CHURCH of CHRIST

SUNDAY SCHOOL 10:00
WORSHIP SUN 11:30
BIBLE CLASS MON 7 PM

3288
CHARLES AVE.

# CHARLES AVENUE

The first African-American community of the South Florida Mainland settled in Charles Avenue in the 1880's. Primarily from the Bahamas, they came via Key West to build the Peacock Inn and other dwellings and work there. Bringing first-hand experience in tropical construction and materials with them, they played an invaluable role in the early development of the area.

Mrs. Evelyn Brady (*left*) an elder of the United Christian Church of Christ (founded in 1952 by Bishop Claude Mincey and now under the aegis of Bishop Dr. Marthena "Tina" Dupree) reflects on the community's proud history.

Historic buildings include the adjacent Odd Fellows Hall, erected by a secret fraternal organization whose American Order was founded in 1819. The Hall served as a community center and library and it was here that dances, parties and dinners were held. Many parades took place in the West Grove in those days and they always started and ended there. The Macedonian Baptist Church is home to the oldest African-American congregation in the area and the A.M.E. Methodist Church housed the community's first school.

# PLYMOUTH CHURCH

This beautiful mission-style church (*overleaf left*), traces its roots to a Sunday school, started by Mrs. Isabella Peacock, an English immigrant proprietor of the Peacock Inn in 1897.

Through the endeavours of Rev. George Spalding and the generosity and support of Mr. and Mrs. Arthur Curtiss James and George E. Merrick, (whose father had been the second minister of the church) it was inaugurated in 1917.

The church was designed by architect Clinton McKenzie and hued out of coral rock by Felix Rabon, an inspired Spanish Master stone mason who used the simple time honored tools of his trade – a trowel, T-square, plumb line and hatchet. A magnificent 300-year-old door from a monastery in the Pyrenees was acquired by Harriet James and added in 1928.

OVERLEAF RIGHT: *Sculpture by Romero Britto, Black Beard's Beach.*

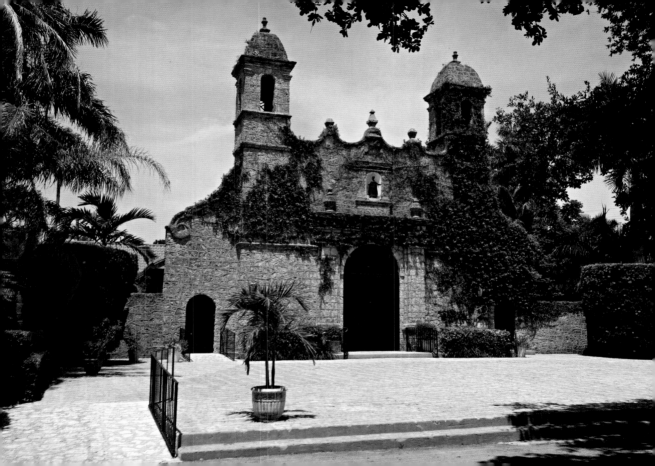

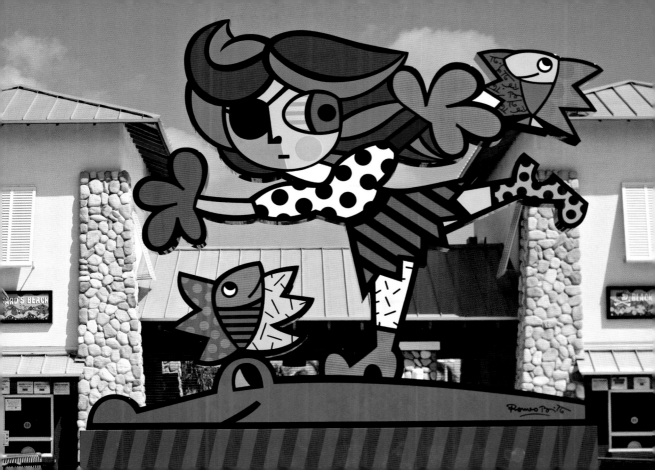

# BRITTO IN MIAMI

The outdoor sculptures of Romero Britto the Brazilian born, Miami based artist of world-renown, graces many outdoor spaces in Miami's urban landscape.

His enchanting work is fresh, graphic, vibrant, flamboyant and delightfully fun-loving with nuances reminiscent of Pop Art and Picasso. It instantly evokes emotions of joy and delight in both young and old alike.

# THE BARNACLE

The Barnacle is Miami's oldest home in its original location. It is set in a forest of tropical hardwood hammock, the last of its kind in the area and has an expansive lawn fronting Biscayne Bay. The Barncale is perfectly preserved, as if in a time warp, offering visitors a nostalgic glimpse of what life was like, before Henry Flagler's railroad came to Miami in 1896. Back in those days, there were no roads, only a common community trail between neighbors's yards and all people and supplies came by boat.

The Barnacle (a marine crustacean often attached to the keel of boats) was the name of the home of Commodore Ralph Monroe (1851-1933), a pioneer photographer, author, sail boat designer and environmentalist.

Monroe visited Biscayne Bay in 1877 and was captivated by the climate, the secluded isolation and the ethnic diversity and warmth of the people. He and his family became prominent members of the fledgling community.

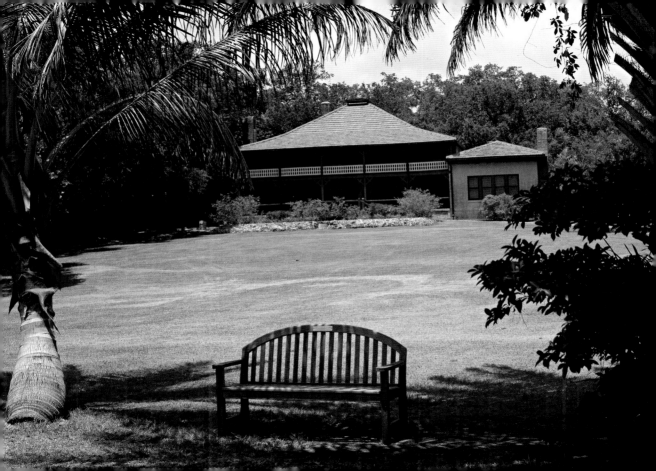

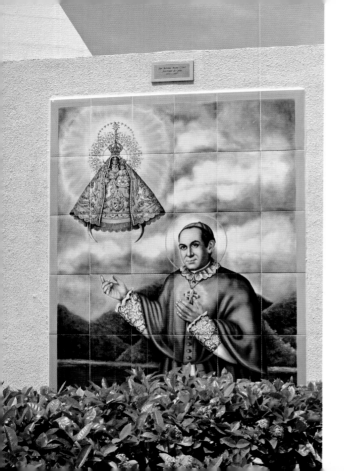

# CUBAN CATHOLIC CHURCH

*Ermita de La Caridad*, the Cuban Catholic Church dedicated to the Cuban Patron Saint, The Virgin of Charity, was founded in 1967. The sea-facing edifice includes a shrine housing the image of the Virgin, originally from the parish of Guanabo Cuba and brought to Miami in 1961. Orientated symbolically towards the island, the church's alter contains earth from the various provinces of Cuba that was fused with water on a raft in which fifteen crew perished while seeking to escape Cuba. The distinctive conical shaped dome symbolizes a beacon. The church provides the Cuban community of Miami, in exile because of communism, with an important spiritual and symbolic bridgehead between Miami and the beloved country of their birth.

   Many Cuban refugees living in Miami have suffered greatly, many having not only lost their freedom, their homeland and every thing they possessed, but have had to endure the pain of separation from and the death of loved ones.

   The church provides an important rally point for diasporic nationalism within a religious and social context in Miami, their new found home.

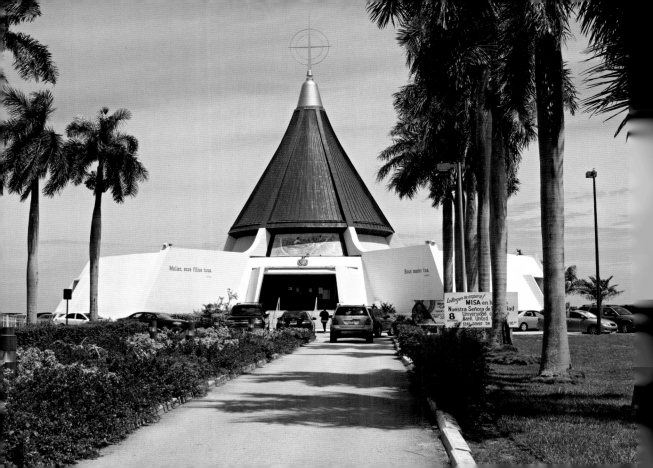

# LITTLE HAVANA

La Pequeña Habana or "Little Havana", a neighborhood of Miami, is approximately bounded by the Miami River (north), SW 11th Street (south), SW 22d Avenue (west) and 1-95(east). With the influx of Cuban refugees to the area in the 1960s, Little Havana, (named after the Cuban capital) has become a microcosm of Cuban-American social, cultural and political life in Miami.

The pungent aroma of cigars and the strong fragrance of Cuban coffee permeate the tropical air at Máximo Gómez (Domino) Park, in the heart of Little Havana's Calle Ocho. Intensely focused, sociable domino-playing elderly men (and occasionally women) sit sheltered from the bright sunshine, around tightly packed tables, playing their favorite game against a backdrop of vivid murals and bronze statues depicting historical figures.

The annual Calla Ocho Street Fair, the most popular community event in the area, attracts musicians, performers and artists who captivate both visitors and locals alike.

RIGHT: *A bronze bust of Máximo Gómez y Báez, a Cuban revolutionary hero who fought against Spanish oppression in the late Nineteenth Century.*

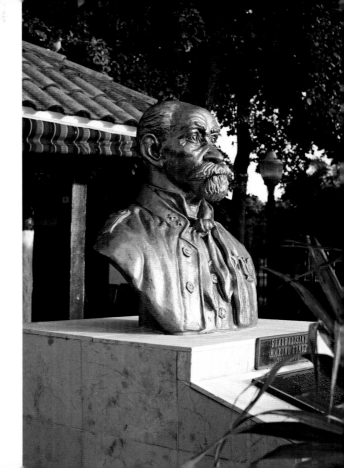

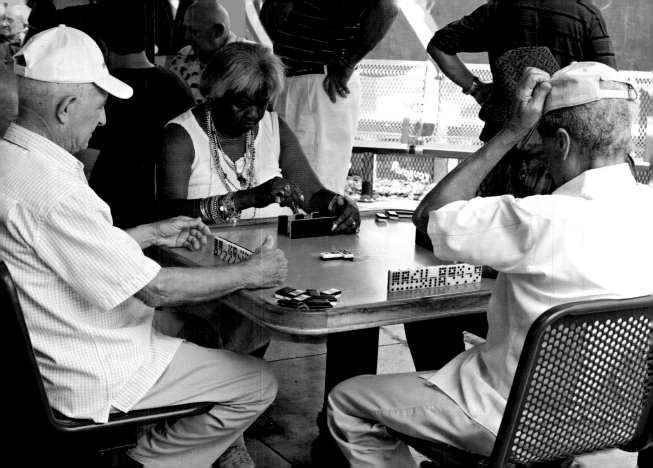

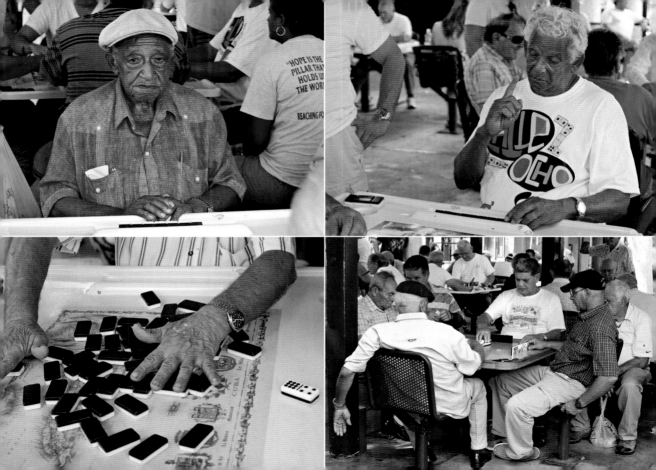

Dominica  Sta Lúcia  Barbados  Granada  Vene

# THE TOWER THEATER

The Tower Theater in Little Havana is a distinctive Art Deco landmark. It was designed by Robert E. Collins, opened in 1926 and remodelled by Robert Law Weed in 1931.

As the demographics of the area changed, with the 1960s influx of Cuban refugees, the theater played an important role in providing an introduction to American culture and entertainment to the newly arrived Cuban community. By popular demand, the management began to add Spanish sub titles to the films and also included some Spanish films with English subtitles. It became known to many Cuban Americans affectionately as Teatro Tower.

After almost 60 years, it was sadly closed to the public in 1984. In 2002 The City of Miami authorized the Miami Dade College to manage the theater operations, under the Cultural Affairs Dept. and it once again provides a historical venue for cultural activities, films with Spanish subtitles, exhibitions and the like.

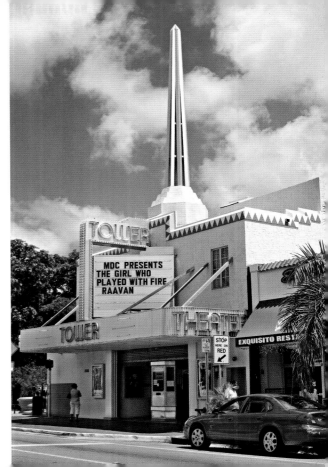

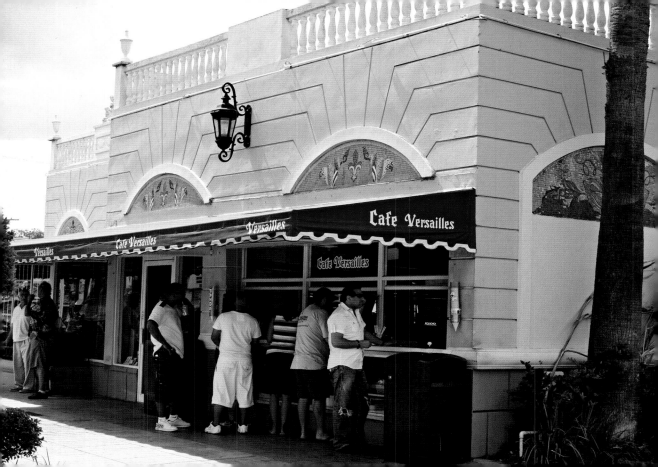

## CAFE VERSAILLES

Cafe Versailles on Calle Ocho is a one-time French cafe with mirrored walls purporting to emulate the Palace of Versailles in France. Curiously it's decidedly Cuban in every other respect. The walk-up service window is a popular place for campaigning politicians, the Latin communities "heavy hitters" and local Cubanos full of lively conversation, debate, and humor – a great spot to have an empanada and a shot of Cuban coffee while watching people coming and going.

## THE BAY OF PIGS MEMORIAL

The Bay of Pigs Invasion, (known as *La Batalla de Girón*, or *Playa Girón* in Cuba) was an unsuccessful mission by a dedicated CIA-trained force of Cuban exiles to invade Southern Cuba. With the support of the US government armed forces during the early presidency of John F. Kennedy, the aim was to overthrow the Cuban government of Fidel Castro in 1961. The original plans for an invasion were ordered by predecessor US President Dwight D. Eisenhower in 1960.

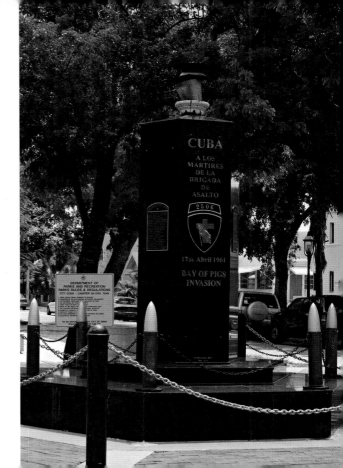

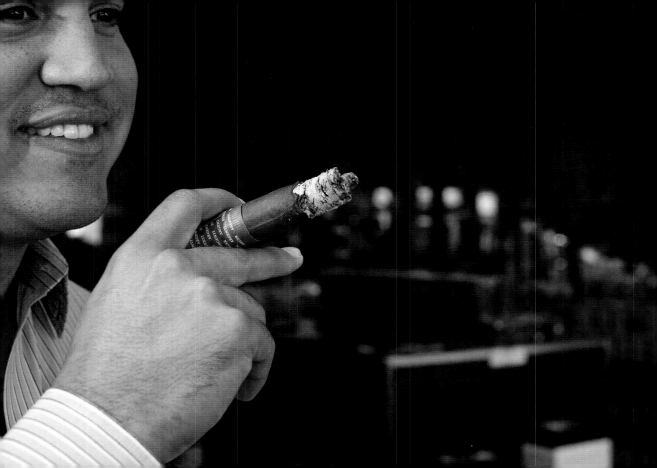

# CUBAN CRAFTERS

Cuban cigar rollers (*Torcedores*), are highly respected in Cuban society and culture and it is clear to see why when watching the labor-intensive seven-part process from leaf selection to finished cigar (*totalmente a mono*) entirely by hand at Miami's Cuban Crafters. As a celebrated grower of tobacco and boutique premium cigar maker, Cuban Crafters cigars are prized by aficionados the world over. There *torcedores* produce cigars with astonishing dexterity, artistry and skill, in various shapes, sizes, varieties and wrapper shades, to satisfy the most discerning connoisseurs. The name "cigar" for a tightly-rolled bundle of dried and fermented tobacco, lit and drawn into the mouth, is derived from the Mayan-Indian word for smoking "sikar" which became "cigarro" in Spanish.

In 1962 President John F. Kennedy imposed a trade embargo on Cuba making it illegal for US residents to purchase or import Cuban cigars. Nowadays cigar factories in Miami source Cuban Tobacco planted in such countries as the Dominican Republic, Cameroon, Honduras, and Nicaragua, and produce the finest Cuban cigars, employing many traditional Cuban *torcedores* refugees now living in Miami.

LEFT: *Jose A. Bermudez of Cuban Crafters enjoys a hand made premium artisan cigar, with the consummate skill of a connoisseur cigar smoker.*

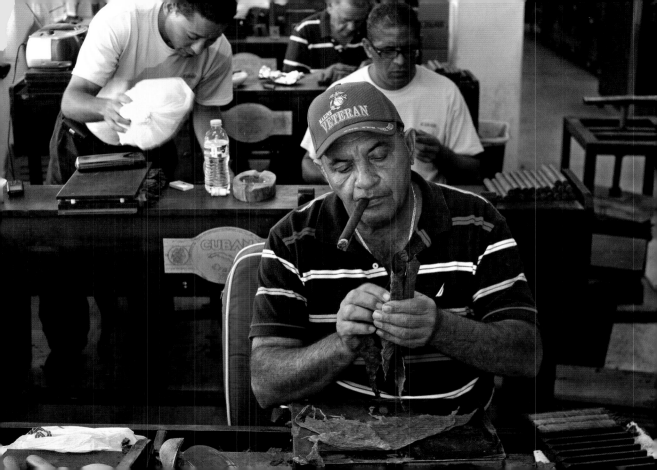

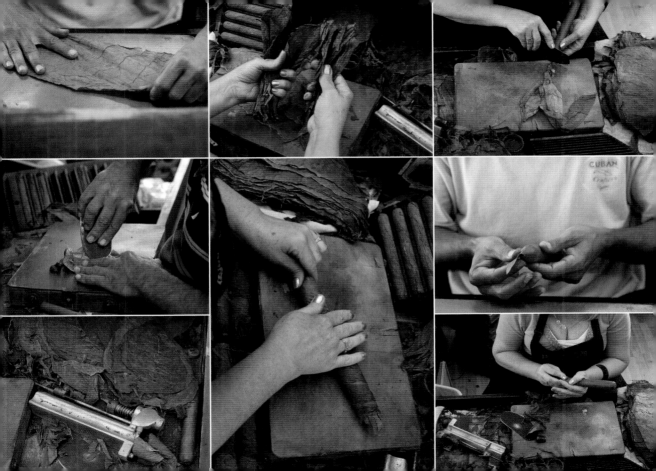

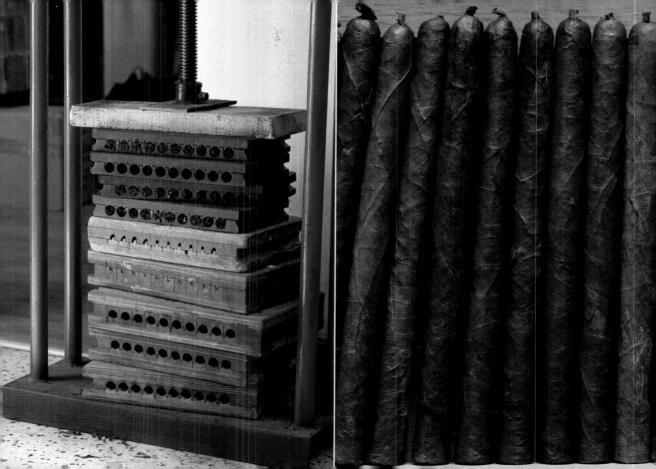

**PARTAGAS**

REAL FABRICA DE TABACOS Y CIGARROS

ESTABLECIDA EN 1845

FLOR DE TABACOS DE PARTAGAS Y Ca

CIFUENTES, Y Ca.

ESTABLISHED IN 1845 IN HAVANA, CUBA

SUPERIOR IMPORTED CIGARS MADE BY HAND
IN SANTIAGO, REPUBLICA DOMINICANA

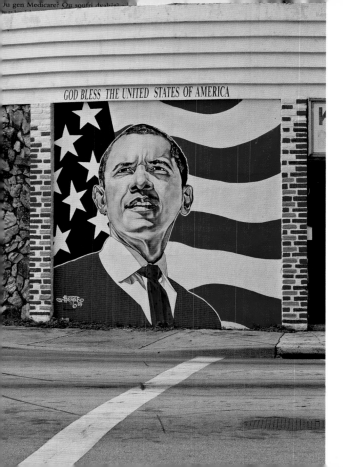

GOD BLESS THE UNITED STATES OF AMERICA

# LITTLE HAITI

Little Haiti (La Petite Haiti) near the Design District and a short drive from Miami Beach, is a multi-ethnic, vibrant community where Haitian Creole and Francophone cultures flourish. The lively commercial district along NE 2nd Avenue is significant to the Haitian Diaspora, being the only area outside Haiti, predominantly populated by Haitians.

The mouthwatering aroma of Creole cooking, savory griot (fried pork), or Haitian-style crab conch washed down with a barbancourt-laced cocktail (Haitian dark rum) tempts the senses. The rhythms of Compas and Racine, popular jazzy Haitian dance music, blare from sidewalk speakers and open doorways. A visual culture of vibrant murals abound, be it featuring Barak Obama or advertising a quincallerie (hardware store), or the sale of beurre chaud (bread).

Once known as Lemon City – lemon trees still grow in some back yards – its demography changed with a large wave of Haitian immigration in the 1970s and 1980s. They brought with them a vibrant and rich cultural heritage, which remains rooted in the country many still refer to as The Homeland.

Haiti, the first Black Republic in the World, celebrated the 200th anniversary of the Haiti Revolution in 2004. Tragically Haiti suffered a catastrophe of epic proportions on 12 January 2010, with a 7.0 Mw earthquake, with at least 52 aftershocks of 4.5 or greater. 230 000 people died, 300 000 were injured and 1 000 000 left homeless.

Little Haiti's iconic, landmark building, The Caribbean Marketplace, was designed to resemble a framed iron market in Haiti's Capital, Port-au-Prince. This rich and colorful complex emulating the gingerbread houses of Haiti opened in 1990. It was built as a pride of place location where locals and visitors could meet, greet and trade in congenial, ethnically authentic surroundings. Designed by Charles Harrison Pawley, a Haitian born and Miami-bred architect, it won the prestigious National Honor Award in 1991 from the American Institute of Architects. The Caribbean Market initially thrived and then sadly failed. The City of Miami took it over and closed the facility, which lay dormant for years. Miami officials are, it is believed, planning to revive it. Though many prosperous and second generation Haiti-Americans have moved north of the City, Little Haiti remains the community's cultural hub.

Libreri Mapou is a quaint bookstore and cultural center, where books in Creole, French and English are sold. Poetry readings dance practice, meetings and other cultural activities take place there. The owner, Jan Mapou founded Sosyete Koukouy (The Society of Fireflies) for the cultural presentations.

A triangle of faiths forms an integral part of Haitian spiritual life. Roman Catholicism, Protestants and the powerful mystical practice of Vodou (Voodoo).

The Church of Notre Dame d'Haiti's stained glass window depicts the life of a recently canonized saint – Pierre Toussaint who was born a slave in Haiti and became a society hairdresser and philanthropist in New York. The Grace United Haitian Methodist Church serves the Haitian community with services in Creole.

Though there are no doubt many Vodou shrines in Little Haiti the only one open to the public is in the local Botanicas shop. There they sell fresh herbs, rows of colored candles and matching scarves, oils, perfumes and of special note, small figures suitable for both Christian or Vodou practices.

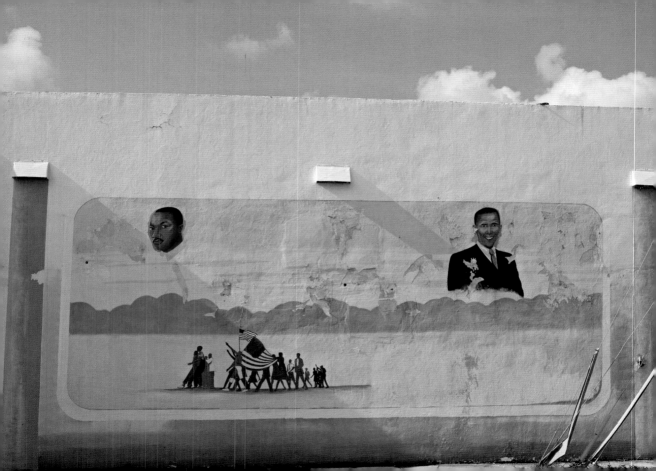

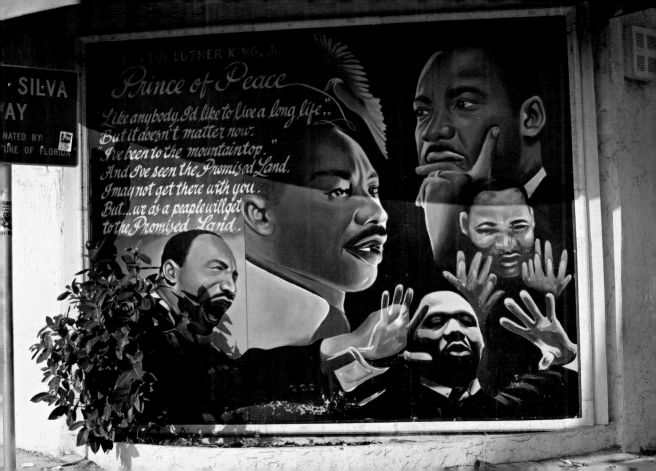

# BACARDI BUILDING

The Bacardi Buildings, a blend of Modern and Tropical Deco, are unique and distinctive examples of the Latin influences to be found in certain Miami Modern buildings (MiMo) so typical of 20th Century Miami.

These masterpieces of architectural and decorative collaboration have by popular consensus now been awarded historic designation. The original tower building was designed by architect Enrique Gutierrez of Puerto Rico in 1963. The structure of reinforced concrete overlaid with two huge "azulejos" (ceramic tile murals) in traditional Spanish blue and white is the work of the accomplished painter and ceramicist Francisco Brennand of Recife, Brazil (born in 1927).

The murals are made up of 28 000 hand painted, glazed and baked 6x6 inch tiles surrounded by a marble border. The Spanish traditional blue and white tiles would have pleased Don Facundo Bacardi Massó, a Catalan wine merchant born in Sitges, Catalonia in Spain, who immigrated to Cuba in 1830. There he pioneered filtering rum through charcoal, stored it in oak barrels and founded Bacardi in Santiago de Cuba in 1862. Like many others, the Bacardi family fled the country after Fidel Castro's revolution in the late 1950s, settling in Miami.

The square building of two floors to the west side of the plaza was added by Bacardi in 1973. Designed by architect Ignacio Carrera-Justiz of Coral Gables, it is raised 47 feet off the ground, cantilevering out 24 feet on each side of a central core and designed to withstand hurricane-force winds. The four enormous walls are embellished with colorful hammered glass tapestries of modern abstract design in chunks one inch thick. They were designed and manufactured in France by S.E.A.R. under the direction of Gabriel and Jacques Loire of Chartres after the original painting by German artist, Johannes M Dietz.

## MIDTOWN MIAMI

Midtown Miami is the newest subdivision of Wynwood, one of the City of Miami's oldest, most historic neighborhoods just north of Downtown and south of the Design District. It includes the subdivisions of the Miami Fashion District, the Wynwood Art District and Edgewater.

The Midtown area, known as "Little San Juan" and "El Barrio" is historically the home of the Puerto Rican community who migrated there from the island and the northeastern cities in the 1950s. The sound of guitar's and maracas playing jibaro-style music and the aromas of lechon-roasted pig and arroz con gandules (rice with pigeon peas) for many Puerto Ricans from the area became a fading memory as the area's demographics changed. The former abandoned and derelict railroad yard for Florida's East Coast Railroad underwent a lively urban renaissance offering the ultimate in urban life style. Midtown is a place to work and play within a sophisticated trendy environment, with great appeal to the young upwardly mobile set. Art is an integral part of the scene with the district hosting contemporary art fairs during Art Basel, Miami Beach.

## DESIGN DISTRICT

The Design District, north of Midtown Miami is within the Buena Vista and southern extremity of the Little Haiti neighborhood. It has more than 130 art galleries, showrooms, antique dealers, creative services, restaurants and bars and has been described as being reminiscent of New York's SoHo District with a Miami touch.

RIGHT: *This imposing, handmade ceramic brick sculpture, a Midtown landmark, is entitled* "BRICKHEAD PLEASE STOP" *and is one in a series of public displays around the world by the renowned sculpture James Tyler.*

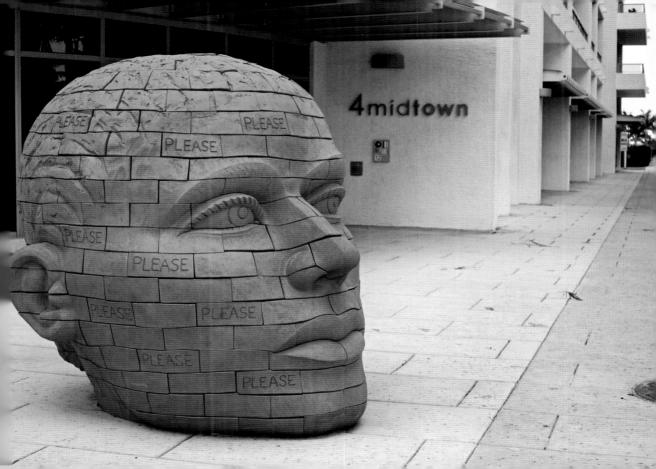

RIGHT: *In 1921 T.V. Moore the "Pineapple King", transformed one of his pineapple plantations into a business district and built an imposing three story furniture store, The Moore Furniture Building, around the small corner building that was then the Buena Vista Post Office. This fine example of architecture, opened in 1922. It is located in the Design District at 4514 NE 1st Avenue.*

# FREEDOM TOWER

This distinctive Miami landmark, located at 600 Biscayne Boulevard on the Wolfson Campus of Miami Dade College, is a 1925 Spanish Renaissance Revival edifice, designed by George A. Fuller. It's design elements were in part, inspired by the Giralda Tower in Seville, Spain. The building was originally the headquarters and printing facility for "The Miami News", until 1957, when they vacated the building and moved to new modern premises on the Miami River.

The Freedom Tower is of special significance and holds a place in the hearts of Miami's Cuban Community. Cuban refugees fleeing Castro's communist regime, passed through its doors, then a government facility, to process, document and provide medical and dental services to the refugees, starting a new life in Miami in the 1960s.

The major influx of Cuban refugees ended in 1972 and in 1974, the Government sold the building and it passed to several successive owners. In 1997 the building was purchased by Jorge Mas Canosa, founder and leader of the Cuban American National Foundation, restored and converted into a memorial to the Cuban Refugees. Freedom Tower was added to the U.S. National Register of Historic Places in 1979 and in 2008 it was designated a U.S. National Historic Landmark.

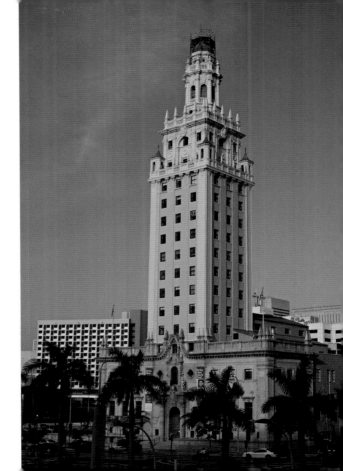

*Fire Escape*

*Design and Architecture Senior High School, Design District*

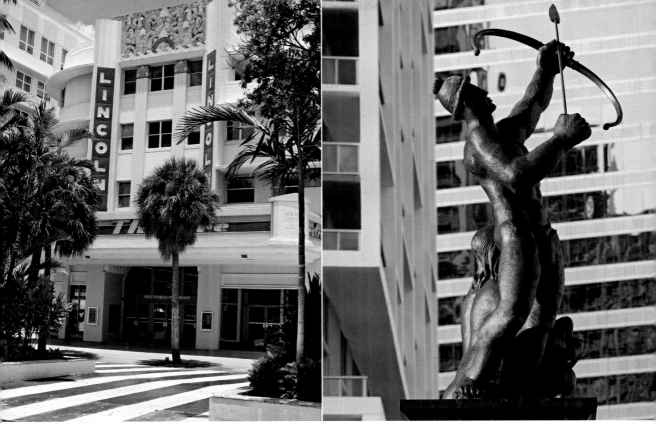

*Lincoln Theatre*

*Tequesta Statue by Manuel Carbonell, Brickell Avenue Bridge*

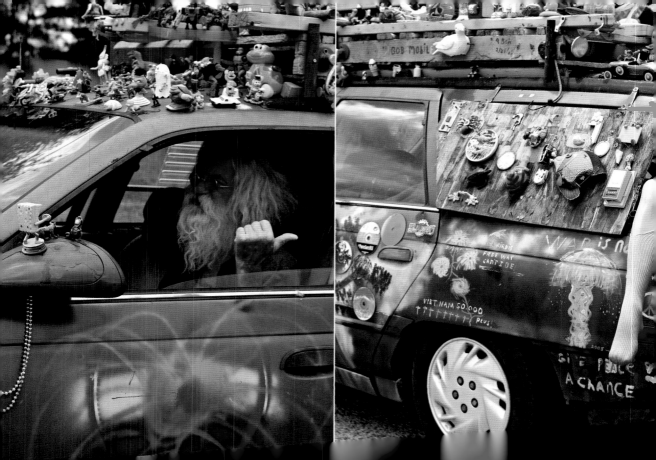

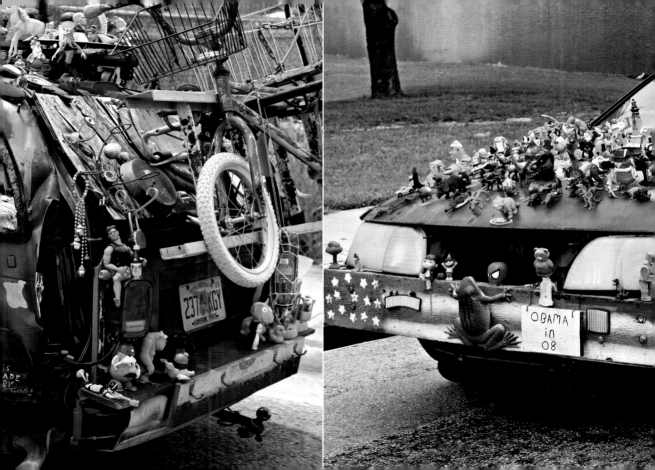

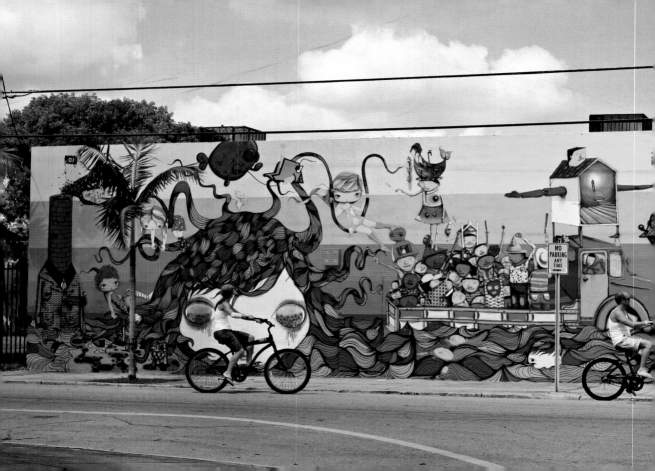

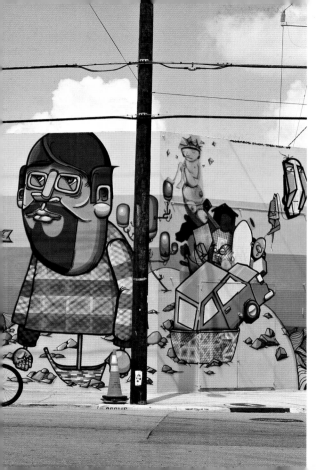

# WYNWOOD ARTS DISTRICT

The Wynwood Art District was founded by a group of art dealers, artists and curators Mark Coetzee and Nina Arias in 2003. The concept was based on "Art Night", a similar initiative Mark had started in his home town, Cape Town, South Africa.

The Wynwood Art District is home to over forty galleries, five museums, three collections, seven art complexes, twelve art studios and five art fairs. The historical and centrally located neighborhood incorporates the Miami Fashion District, the Wynwood Art District as well as its newest subdivision, Midtown in the City of Miami, just north of Downtown. The walls of the buildings in the area are a virtual outdoor art gallery that inspire locals and visitors with bold graphic visual statements.

On the second Saturday of every month visitors can partake in the Wynwood Art Walk – a walking tour through the area, once aptly described as being "like speed dating for art lovers."

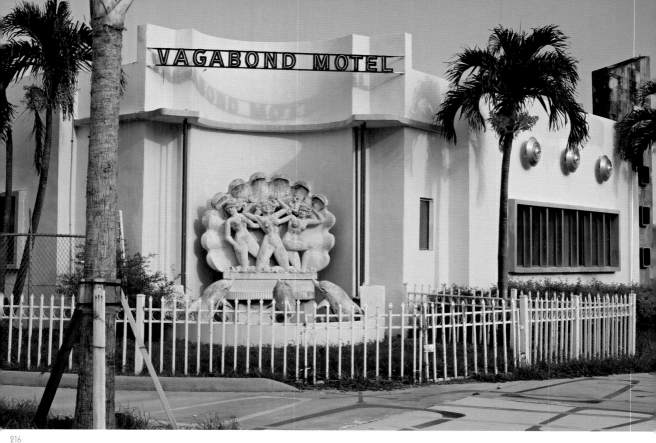

# MIMO MIAMI

Miami Modernist Architecture or "MiMo", an acronym coined by Miami Beach resident, Ronald C. Robinson, is a distinctive style that originated in Miami and South Beach in the 1940s and 1950s. It was a natural pendulum swing away from modernist and post war austerity. As life began to return to relative normality, modest functionality gave way to expressions of material excess, glitz, glamour, fun and fantasy that prevailed. This new style took root in the Biscayne corridor, mid Miami Beach along Collins Avenue, Midtown, the Design District and Upper Eastside.

The Cinco de MiMo (a play on Cinco de Mayo) festival is held annually in early March to celebrate and promote awareness of these valuable architectural and cultural treasures unique to Miami and Miami Beach.

The unique fantasy cut-out cloud signage of the Vagabond Motel sits atop a tapered brick column with a diagonal shower of stars that twinkle at night from "bean pole" supports. These gently swaying palm trees and a balmy Miami night are evocative of the good life and good times of the era.

On the northeast building of the Vagabond Motel, in a grotto recessed into a concave corner, three "sirens of the deep" frolic in a seashell cartouche to the obvious delight of dolphins.

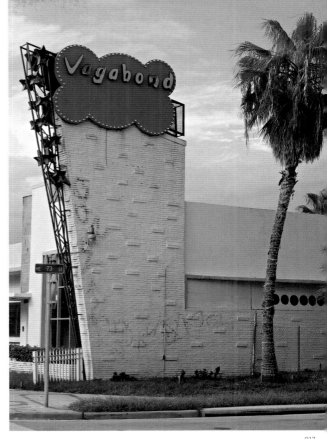

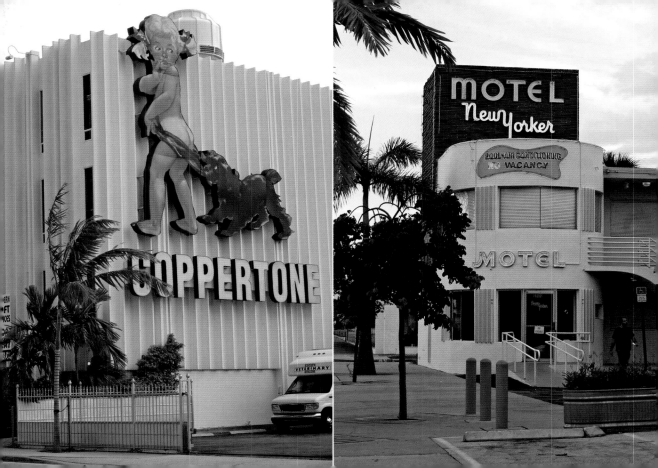

# MIAMI'S CUTTING EDGE MEDICAL SCIENCE

The Leonard M. Miller School of Medicine at the University of Miami is home to the world's leading neurological research facility dedicated to finding a cure for spinal cord injuries and paralysis. This has been made possible by the indomitable spirit and tireless enterprise of once a 220 pound Citadel linebacker who became a quadriplegic, unable to move a muscle below his neck, due to a tragic accident during a football game in 1985.

Through his heroic endeavours, Marc has been an inspiring example of heroic fortitude and courage in the face of great adversity. He started the Buoniconti Fund in 1999, dedicated to the research of spinal cord injury and paralysis and has raised more than $200 million. Miami Project scientists plan to promote nerve growth in damaged spinal cords, a procedure that shows promise in current research and testing.

The dynamic work of Marc Buoniconti and the Project scientists continue to make a meaningful contribution to medical science, save countless lives, improve the levels of care and bring hope to victims of spinal cord injury and paralysis the world over.

The Sylvester Comprehensive Cancer Center at the University of Miami School of Medicine is literally at the cutting edge of robotic radio surgery and clinical excellence. Using the Accuray CyberKnife®, the most powerful available in Florida, they are able to deliver highly concentrated doses of radiation with stunning precision to treat tumors anywhere in the body non-invasively. The CyberKnife uses a radiation-beam projector mounted on a robotic arm that can move completely around a patient and its superior accuracy allows the Sylvester radiation oncology team to destroy cancer cells while sparing healthy tissue, thus reducing side effects and treatment time.

OVERLEAF RIGHT: *Radiation therapy technologist and medical dosimetrist, William Amestoy, RTT(R)(T) M.D. pictured with the CyberKnife, is a member of the radiation oncology team.*

OVERLEAF LEFT: *Statue of the late Harcourt M. Sylvester, with a letter from a grateful patient. His vision and gift of $27.5 million to the University of Miami School of Medicine in 1986 to establish a cancer center, has brought hope to many and saved countless lives.*

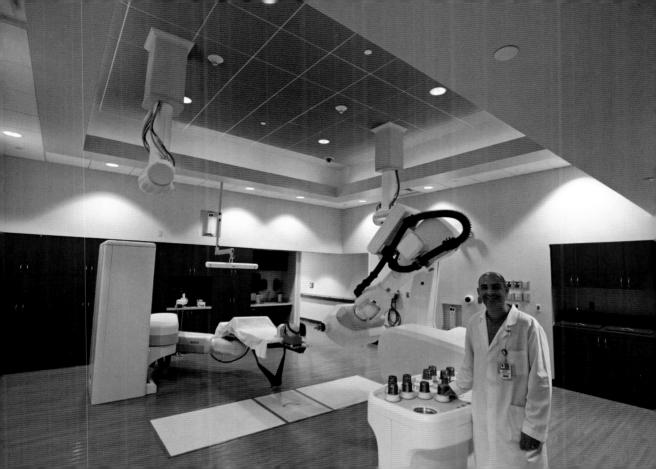

*The Doral Golf Resort & Spa in Miami is a celebrated golfing destination with five championship golf courses.*

*Perhaps the best known of its courses is the Dick Wilson designed "Blue Monster" which has played host to the PGA Tour as well as the WGC-Cadillac Championship.*

*Miami International Airport (MIA), founded in 1928, is the largest U.S. gateway for Latin America and the Caribbean.*

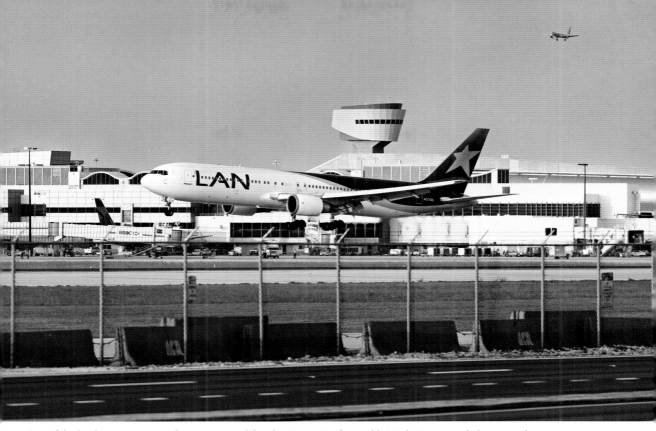

*One of the leading international passenger and freight airports in the world, it is being expanded to more than seven million square feet.*

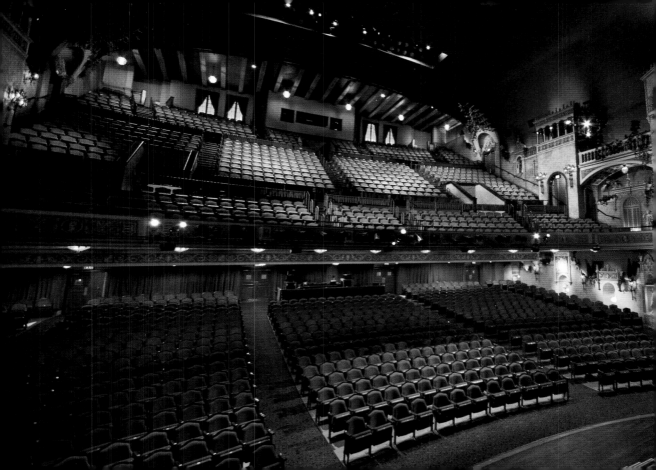

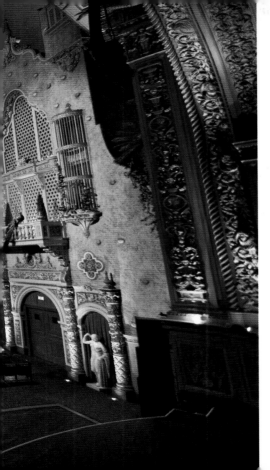

# OLYMPIA THEATER

The awe-inspiring Olympia Theater at the Gusman Center for the Performing Arts is resplendent in the grand tradition of theaters and movie palaces of a bygone era, when men of the age dressed in black tie and ladies donned full-length sequined evening gowns and mink stoles – a time when going to "dinner and the movies" held a special sense of occasion.

Wanting to preserve this enriching cultural moment in time, businessman and philanthropist Maurice Gusman saved the octogenarian "grand old lady" from the breaker's ball in the 1970s to serve as the home of the Miami Philharmonic Orchestra. In so doing he enabled future generations to be entertained, while experiencing and reflecting on a bygone age of elegance.

Designed by John Eberson, the pre-eminent theater designer of his day, the theater on historic Flagler Street in downtown Miami opened in 1926. It has a spectacular Moorish courtyard theme under a "night sky" with stars that twinkle and clouds that roll by. The superb acoustics are richly detailed with a cleverly illuminated eclectic mix of stylized Iberian ornature, classical statues and striking three dimensional theatrical moldings depicting Shakespearian characters.

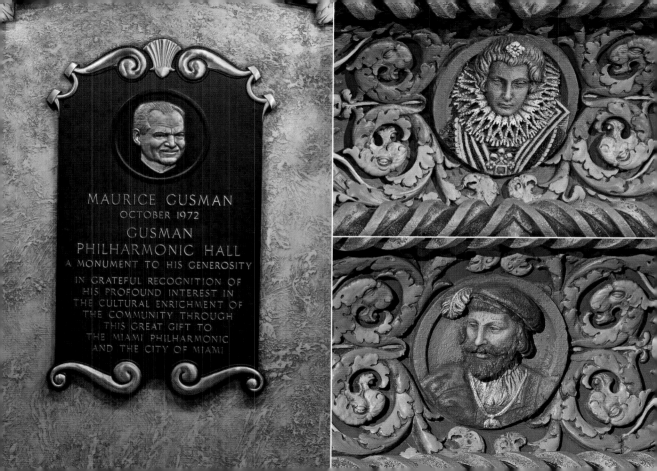

MAURICE GUSMAN
OCTOBER 1972

GUSMAN
PHILHARMONIC HALL
A MONUMENT TO HIS GENEROSITY

IN GRATEFUL RECOGNITION OF
HIS PROFOUND INTEREST IN
THE CULTURAL ENRICHMENT OF
THE COMMUNITY THROUGH
THIS GREAT GIFT TO
THE MIAMI PHILHARMONIC
AND THE CITY OF MIAMI

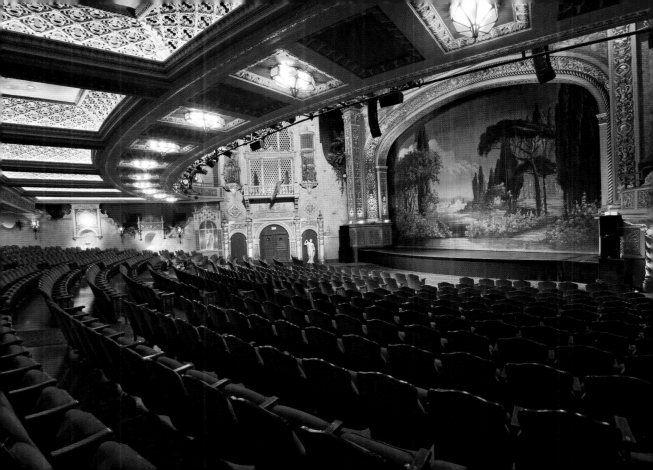

*Operating on 22.4 miles of rail line, the Miami Metro is Florida's sole rapid transit metro system.*

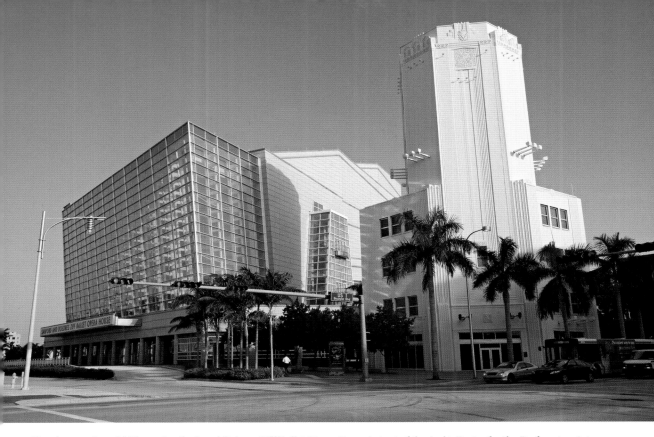

*The ultra-modern 2400-seat Sanford and Delores Ziff Ballet Opera House is part of the Arsht Center for the Performing Arts.*

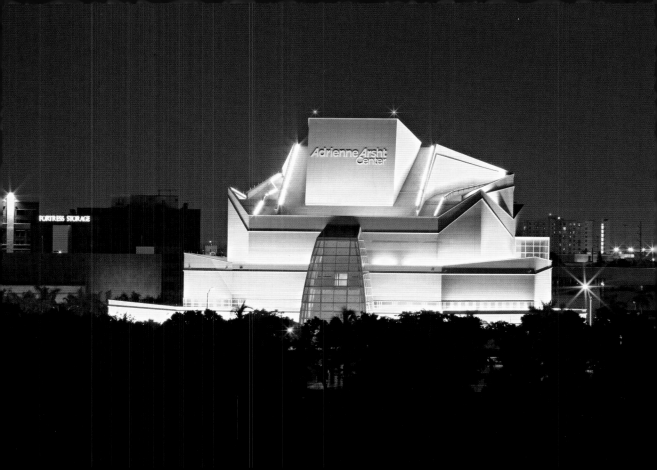

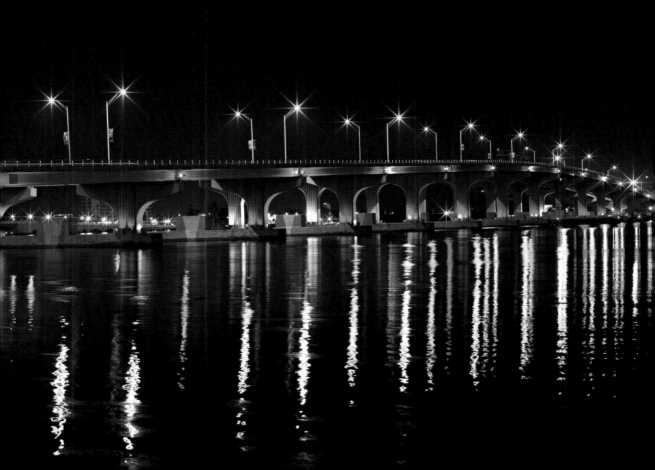

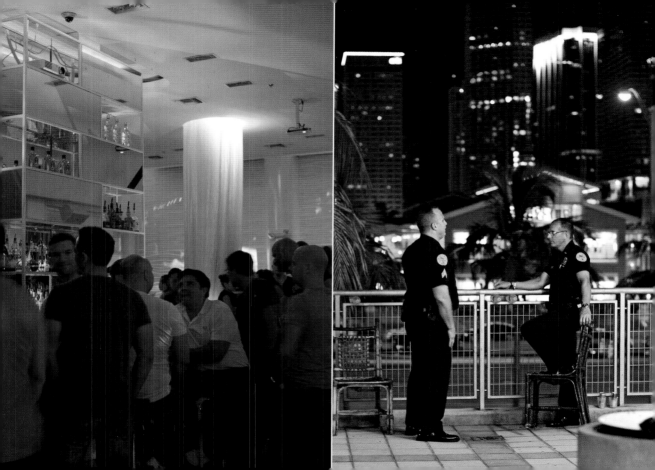

RIGHT: *Each night a classic Miami scene unfolds with the illumination of the six-lane MacArthur Causeway that crosses Biscayne Bay. As dusk turns to night magenta, pink and purple hues at panache to Miami's skyline.*

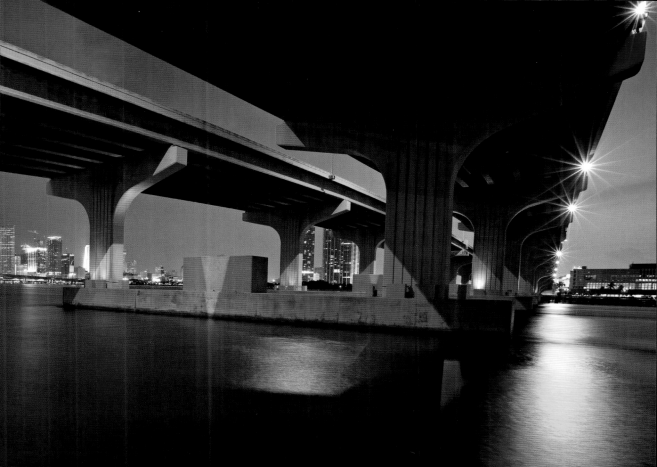

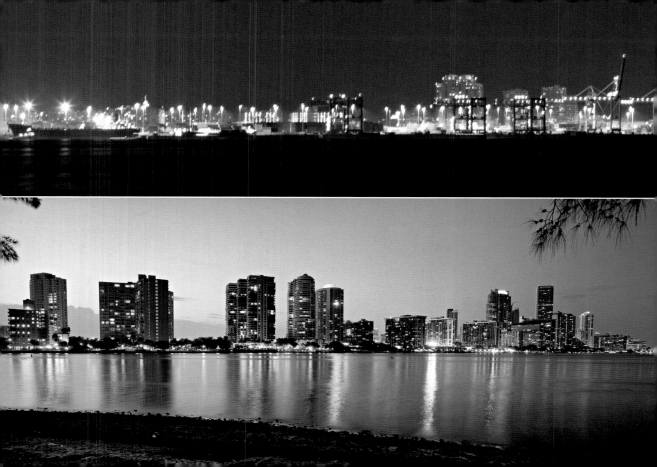

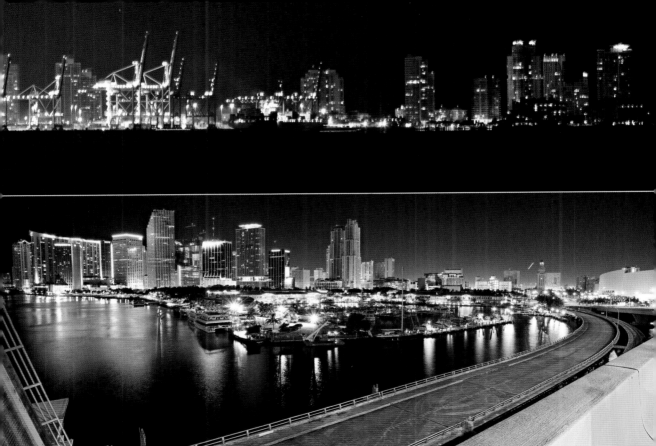

# MIAMI, CRUISE CAPITAL OF THE WORLD

The Port of Miami is the "Cruise Capital of the World" – having been so for more than four decades, ever since the modern cruise facility was established at the port.

Setting a new industry standard, the Port of Miami partnered with Miami-based Carnival Cruise Lines to complete Cruise Terminals D and E (*overleaf*). These ultramodern facilities when combined, include 175 000 square feet of passenger processing area plus a 55 700 square feet area for baggage handling, U.S. Customs and Border Protection. The terminals are capable of handling mega cruise liners carrying as many as 5000 passengers at a time.

The Port of Miami, the largest port in the state of Florida, and ninth largest in the United States, is host to 24 of the world's leading cruise ships, representing 10 cruise lines, four of which have their world headquarters in Miami-Dade County. The cruise ship passenger numbers play a significant role in contributing to the local economy, generating an annual income estimated to be more than $17 billion and providing 176 000 jobs.

Of the millions of passengers passing through the Miami International Airport each year, one out of every three is booked on a cruise from Miami Port. Most cruise ship passengers include a visit to Miami in their itineraries.

# MIAMI, CARGO GATEWAY TO THE AMERICAS

Miami Port is ideally situated at the "global crossroads" and being the nearest major container port to the expanding Panama Canal, is also the "Cargo Gateway to the Americas". Some 20 shipping lines link the Port of Miami with 250 ports in more than 100 countries.

The port primarily handles containers with small quantities of break bulk, vehicles and industrial equipment. With projects such as the deepening of the cargo harbor to 50 feet, the Port of Miami is poised to double its cargo handling capacity with commensurate jobs, adding billions of dollars to the economy.

In 1997, the port undertook a redevelopment program of more than $250 million to meet the changing demands of international shipping. It acquired two state-of-the-art gantry cranes, which are among the largest in the world. There are four refrigerated yards for containers, six gantry crane wharves, seven Roll on/Roll-off docks, break bulk cargo warehouses, and nine gantry container handling cranes.

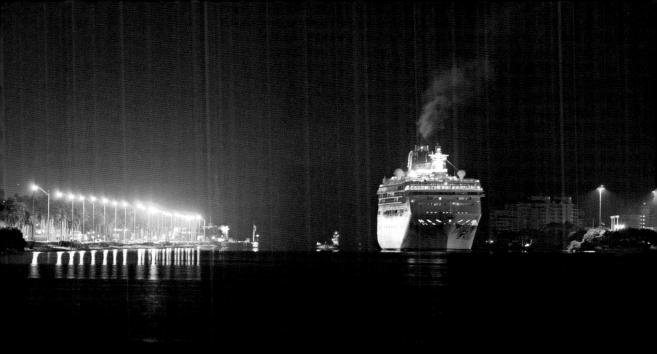

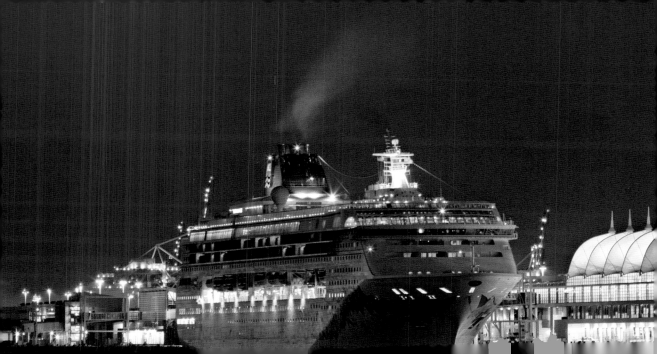

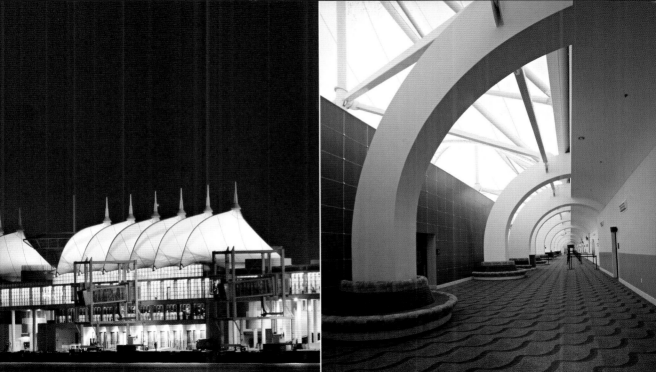

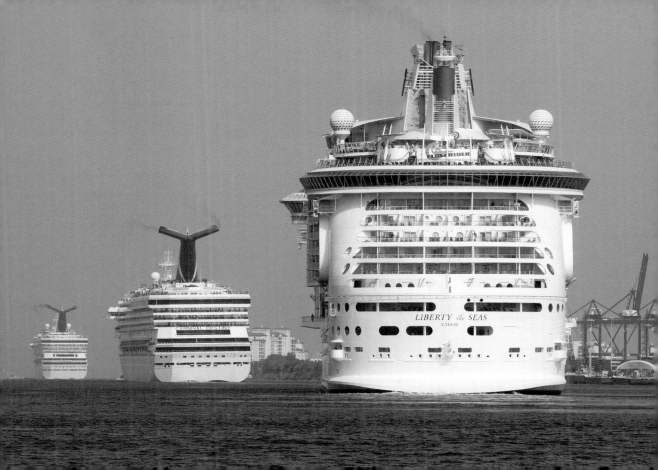

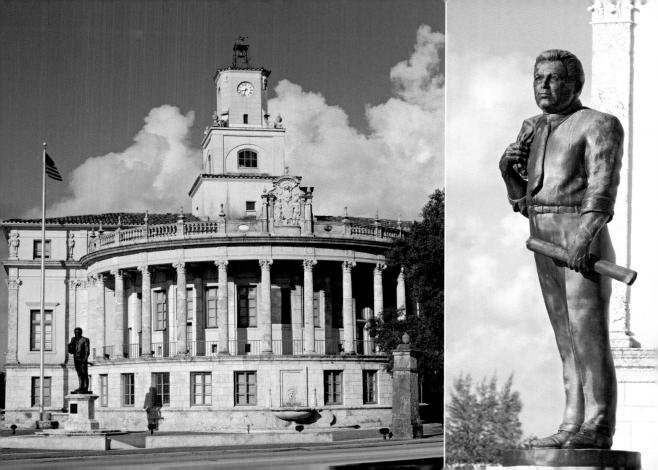

# CORAL GABLES CITY HALL

The Coral Gables City Hall was designed by Phineas E. Paist, the original supervising architect for Coral Gables. It opened officially in 1928 to the delight of George Edgar Merrick (1886-1942), left, the innovator, founder and real estate developer of Coral Gables.

Merrick was a passionate devotee of aesthetic beauty and the City Hall, an outstanding example of Spanish Renaissance style architecture, was of particular significance to him. Its semicircular rotunda is supported by 20 foot outside columns. A rectangular patio, with entrances on three sides, is heightened by a bronze belfry and embellished with a prominent crest centrally displayed on the facade of the balcony. Arcaded loggias, patios, fountains, and old Spanish barrel roof tiles, combined with Florida coral keystone rock and tinted stucco, provided the blue print for the general look and feel of the houses on the wide avenues of Coral Gables – one of the first strictly zoned communities in the United States.

*RIGHT: The Alhambra Water Tower, a spectacular fantasy "lighthouse" (without sea), was built in the middle of residential suburbia, to conceal a water tower. The design is credited to Denman Fink, artistic designer for Coral Gables, circa 1923.*

# GEORGE MERRICK'S UNFINISHED THEMED VILLAGE IN CORAL GABLES

In addition to the strictly controlled planning and predominantly Spanish influence of its architecture, the culturally rich and diverse community of Coral Gables have inherited a unique lesser-known architectural legacy: six internationally themed residential areas from the early 1900s.

The Village Project was a joint venture between George Merrick, The American Building Co. and the former Governor of Ohio, Myers Cooper. Together they planned to build over 1000 themed residences of the highest quality, employing the finest architects of the day. Six of these historical themes were built; French Provincial, Italian, Florida Pioneer, Chinese Village (*left*), French Country Village and Cape Dutch South African. Sadly the devastating hurricane of 1926 and the depression that followed, put paid to the ultimate realization of the project.

Following the ideals of his City Beautiful Movement with alacrity, not withstanding this hiatus in his pursuit of aesthetic excellence and innovation, the legendry founder of Coral Gables, George Merrick, cemented the cornerstone of the City's grace and grandeur for posterity.

# BILTMORE HOTEL, CORAL GABLES

George Merrick and hotel magnate John McEntee Bowman collaborated to build the fabulously opulent Biltmore Hotel in Coral Gables in 1926. It was designed by Leonard Schultze and S. Fullerton Weaver. The hotel was (as now) simply sensational! At the time, it was the tallest building in Florida, eclipsing the Freedom Tower in Downtown Miami and had the largest man-made pool in the world.

The Biltmore's inauguration was a spectacular gala occasion. Special trains marked "Miami Biltmore Specials" transported crowds from the northern cities, the Giralda Tower was illuminated for the first time and champagne corks popped, as couples dressed in long ball gowns and black tie took to the crowded dance floor on the hotel's grand terrace. Hollywood "Who's Who" personified, The Biltmore was an elegant place to dine and to see-and-be-seen. President Franklin D. Roosevelt even had a temporary White House office installed at the hotel when he came on fishing trips to Florida. This was the age of big band jazz, aquatic spectacles, Fred Astaire and Ginger Rogers, Bugsy Siegel and Al Capone and the Duke and Duchess of Windsor. The Riviera had come to America.

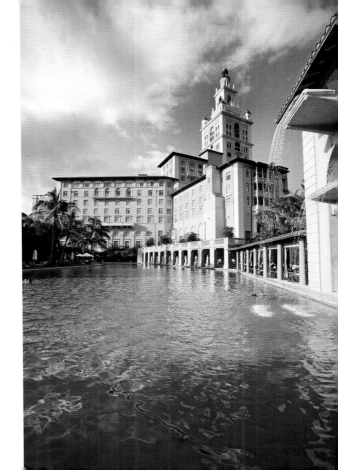

# VENITIAN POOL, CORAL GABLES

The world famous Venetian Pool, in Coral Gables, is the largest fresh water pool in the U.S. and is included on the National Registry of Historic Places. Some 820 000 gallons of spring fresh water is fed from an underground aquifer, now recycled by a natural process. This was once simply a dusty limestone quarry, used for the construction of Coral Gables homes.

In 1924, Denman Fink, artist-architect and uncle of Coral Gables founder George Merrick, transformed it into a spectacular Venetian-themed, Florida-styled aquatic fantasy, complete with vine-covered loggias, shady porticos, three story observation towers, cascading waterfalls, a fountain and a palm-fringed island.

Gondoliers plied its waters, the legendry Esther Williams swam there, as did Johnny Weissmuller of Tarzan fame and an endless parade of bathing belles promenaded over special walkways. As evening fell, on balmy Miami nights, couples sashayed sensuously on terrazzo dance floors to the orchestras of Paul Whiteman, Jan Garber and the like, under a star-studded sky.

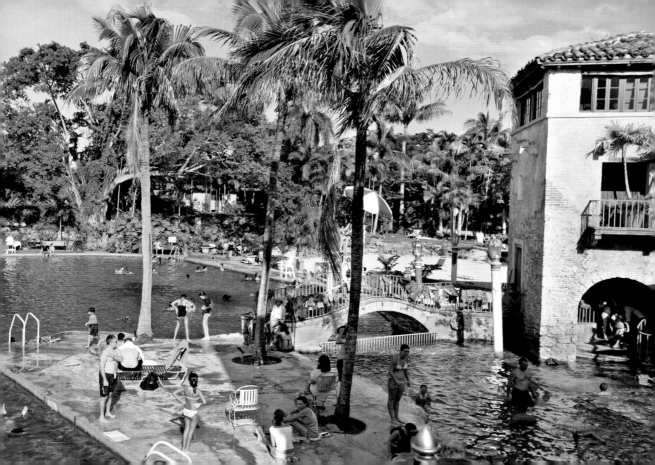

*Miami Children's Museum, provides hundreds of interactive exhibits to enrich and educate children.*

*Mitchell Kaplan, founder of Books & Books, Coral Gables, one of America's most respected independent bookstores.*

RIGHT: *Trained in the age-old European tradition of fine chocolate making, in 1983 Phyliss Geiger founded Peterbrooke Chocolatier in Jacksonville. Today Miami can enjoy the same chocolate that has a loyal following and reputation as the source of wonderful chocolate "art pieces" with a mouth watering selection of luscious skillfully blended, hand-dipped temptations.*

*Miami's spa's are legendary, attracting travelers from all over the world in search of luxurious pampering.*

*The exotic and sumptuous Elemis Spa experience is perhaps the best known of all, drawing inspiration from ten ancient cultures where the six senses of sight, sound, smell, touch, taste and perception are lavished beyond belief.*

# FAIRCHILD TROPICAL GARDEN

Miami is the one place in the continental United States where tropical plants can grow outdoors the whole year round. Its Coral Garden suburb is home to one of the world's pre-eminent tropical botanical gardens.

The Fairchild Tropical Botanic Gardens was founded in 1936 by Robert H. Montgomery, (1872-1953), an accountant, attorney and businessman, and opened to the public in 1938. He was passionate about plant-collecting and named the garden after his good friend David Fairchild (1869-1954) one of the world's great botanical explorers, who guided him in its establishment. The Park was designed by the renowned landscape architect William Lyman Phillips – the leading landscape designer in South Florida during the 1930s. Its mission is exploring, explaining and conserving the world of tropical plants.

The Garden, 83 acres (34ha) in extent, displays extensive collections of rare tropical plants, including palms, cycads, vines and flowering trees. The Garden is a leading center of palm research, horticulture, and conservation. Since the 1930s The Fairchild Tropical Botanical Garden, has emphasized the expansion of plant knowledge, through publications,

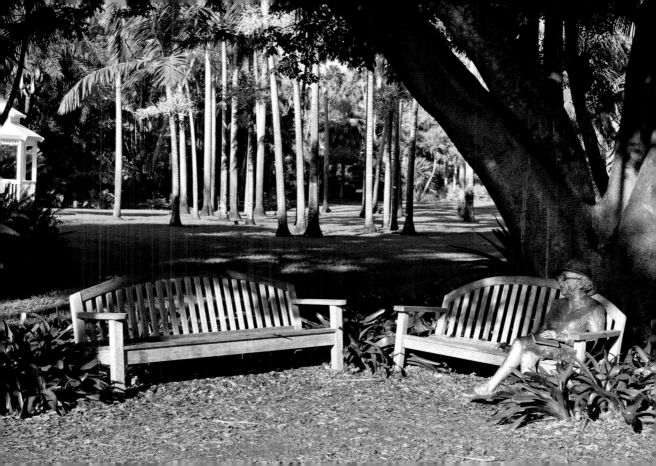

education programs, and research in taxonomy, floristics, conservation, biology and ethno-botany. This tropical Shangri-la is a splendid microcosm of Florida's flora.

On entering the Fairchild Tropical Botanical Garden, one may notice an elderly lady sitting on a park bench under a large shady tree. The lifelike statue of Marjory Stoneman Douglas (1890-1998) is one of many sculptures found in the gardens – both permanent and temporary artworks are showcased in this "open-air" gallery.

Marjory Stoneman Douglas was a journalist, writer, champion of woman's suffrage and a civil rights campaigner but perhaps she was most influential as an environmentalist and author of a book entitled "The Everglades River of Grass" in 1947, which sought to redefine the Everglades as a treasured river instead of a swamp. "All we need really is a change from a near frigid to a tropical attitude of mind" she famously observed.

RIGHT: *A spectacular blown glass tower by Dale Chihuly, Fairchild Tropical Botanic Garden, Miami.*

# UNIVERSITY OF MIAMI

The University of Miami, often affectionately referred to as UM, THE U, U OF M and U MIAMI is an eminent research university committed to the highest standards of excellence. It has more than 15 000 students, almost 10 000 undergraduates, more than 5 000 postgraduates, more than 2 500 full time academic staff and almost 11, 000 full time admin staff. The university was founded in 1925, with its main campus in the city of Coral Gables, on 160 acres of land donated by George E. Merrick.

By the fall of 1926 the devastating hurricane and the collapse of the building boom challenged the first class of 372 students and staff at the fledgling university. The Merrick Building on campus stood half built for over two decades due to economic restraints. Planned by Merrick to be a Mediterranean Revival fantasy, the campus architecture took a different direction. In 1945, under the able direction of Marion Manley, Miami's first female architect and Robert Law Weed, the first Modern campus in the U.S. was realized with a magnificent collection of Subtropical Modernist buildings within a glorious botanical garden setting.

The university also maintains a medical campus at the Miami Civic Center and a marine research facility on Virginia Key.

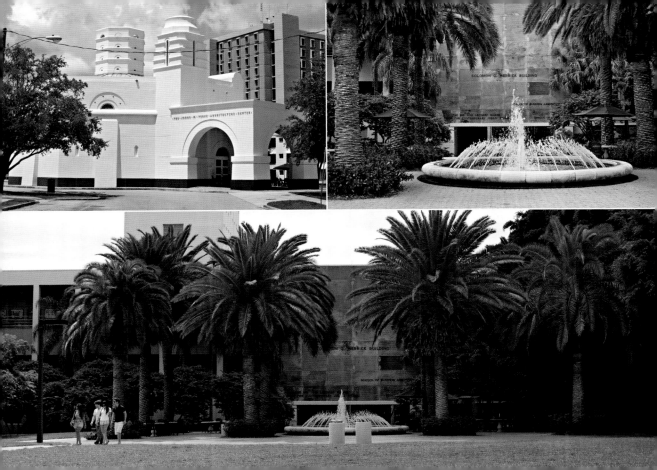

# CAPRI ITALIAN RESTAURANT

Richard Accursio started Capri Restaurant back in 1958. His passion for food in the old style Italian tradition and his endearing flair for making diners feel welcome, has earned him and his family a long list of loyal dinners. Considered by many "in the know" to be the quintessential Italian restaurant of South Dade, the family restaurant is now run by Richard's son James and its wine list has been honored with a prestigious award of excellence by the Wine Spectator.

Over the year's the Accursio's have offered "early bird brigade" specials, with affordable meals that have attracted senior diners. Today, with the changing realities of the financial crisis these "early bird" specials have become increasingly popular with the younger set.

# MIAMI'S EXTRAORDINARY ORCHIDS

Praised through the ages for their exotic, elegant and mysterious allure, orchids continue to fascinate and inspire people the world over. With over 25 000 naturally occurring species, Orchidaceae is the second largest family of flowering plants, equaling more than double the number of the world's bird species. The name "orchid" is derived from the Greek *órkhis*, meaning "testicles", to which ancient Greek philosopher and Botanist, Theophrasus (370-285 B.C.), compared the appearance of Mediterranean Orchis bulbs.

North of downtown Homestead, the affable President of RF Orchids, Robert Fuchs (*left*) tends his orchids with passion and pride as he has done, at the same location, for the last forty years. World renowned and visited by collectors, aficionados and tourists throughout the year, RF Orchids is reputed to have the largest orchid collection to be found anywhere, including an extraordinary selection of fine vandaceous alliance orchids, from exotic species to the newest hybrids and fine mericlones.

The knowledge of Robert Fuchs, Vice President Michael Coronado and the RF Orchids staff is legendary and their horticultural excellence is recognized with hundreds of medals, trophies and accolades from around the world, including more than 900 awards from the American Orchid Society (with over 75 awards for outstanding orchid culture).

# ROBERT IS HERE

Way back in the late fall of 1959, little Robert Moehling, then just six years old, was installed on a rural intersection in Homestead to sell cucumbers by his father who was having a hard time selling his crop. The day seemed like an eternity, without a single customer stopping at the stall and Robert felt downhearted. "They probably never even noticed you", his father said and promptly took two hurricane shutters and made them into a prominent sign with large red letters…ROBERT IS HERE. The next day passers-by flocked to little Robert's stand and in no time all the produce was sold. At this profound, defining moment at the tender age of six years old, a legend was born. Half a century later Robert is still here!

Today, Robert together with his large extended family, continues to sell high quality fresh produce, much of which he farms. At 19200 SW 344 St, Homestead, about two miles from the Florida Turnpike, the Robert Is Here Fruit Stand and Farm is somewhat larger than the original stall but the name still stands proudly bold, enticing curious visitors to this local landmark.

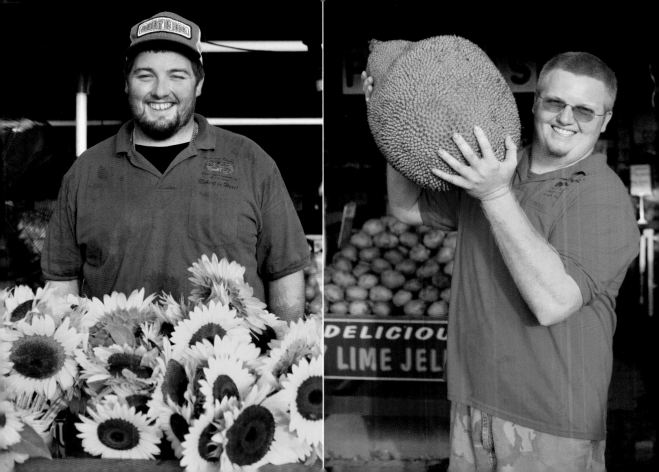

# SCHNEBLY REDLAND'S WINERY

The southernmost winery in the United States, Schnebly Redland's Winery is located in the heart of the Redlands, a large agricultural area about 20 miles from Miami and is part of the Historic Redland Tropical Trail. It takes its name from the clayey red soil of the area, which lies on a layer of oolitic limestone. These fertile lands are hydrated with fresh water from the Biscayne Aquifer. Exotic plants and vegetables thrive here that will not grow else ware in the United States – an enigma to many botanists and horticulturists. It is here on their 96-acre farm that Fresh King, Inc., the husband and wife partnership of Peter and Denisse Schnebly (*left*) grow tropical fruits such as carambola, mango, lychee, guava and passion fruit from which they make their (non-grape) wines. The wine from each fruit is unique and delightfully different.

Tastings can take place in a variety of settings – outdoors amid the natural coral, cascading waterfalls and lush tropical foliage or in the sophisticated tasting room with its conversation-piece painted ceiling and convivial company. Visitors can also take to the dance floor to party informally with friends to a live band just a short stroll away.

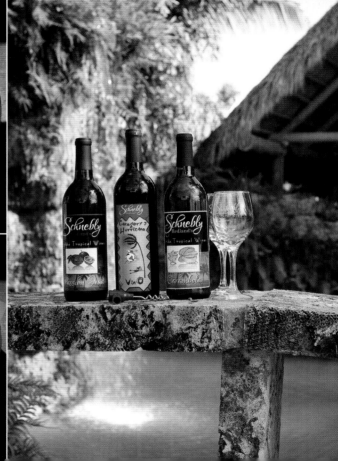

# CORAL CASTLE

Romantic, remarkable and mysterious, Coral Castle has captured the imagination of all that have passed through its gates. The castle and its grounds consist of approximately 1000 tons of megalithic stones, each inexplicably transported, fashioned and erected by a single man, Edward Leedskalnin.

Poor, uneducated and in love, 26 year old Edward was to be married to the love of his life, Agnes Scuffs, a girl 10 years his junior, whom he referred to as his "Sweet Sixteen". When Agnes broke off the engagement the night before their wedding, Edward was left heartbroken and devastated. Shortly afterwards Edward moved to America and with the little money he had, purchased a small piece of land in Florida City. There he lived with his torment in lonely isolation and constructed, painstakingly over 20 years, a massive coral monument which he called "Rock Gate Park", dedicated to his unrequited love.

Working secretly at night by lantern light, Leedskalnin single-handedly moved and sculpted these gigantic stones (some weighing as much as 30 tons) and created highly imaginative and complex masonry objects including a 28 ton obelisk, a Polaris telescope

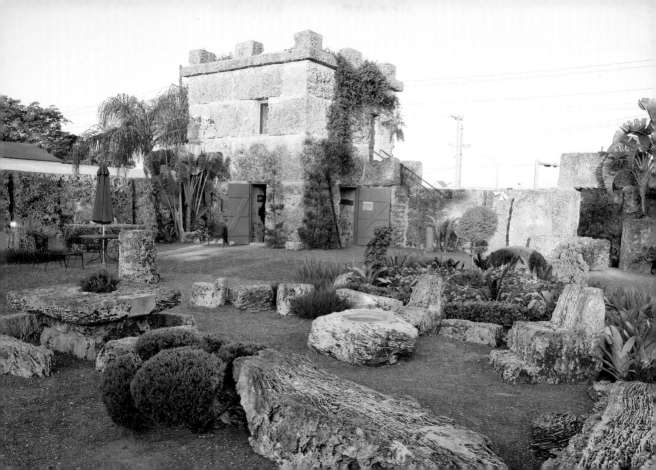

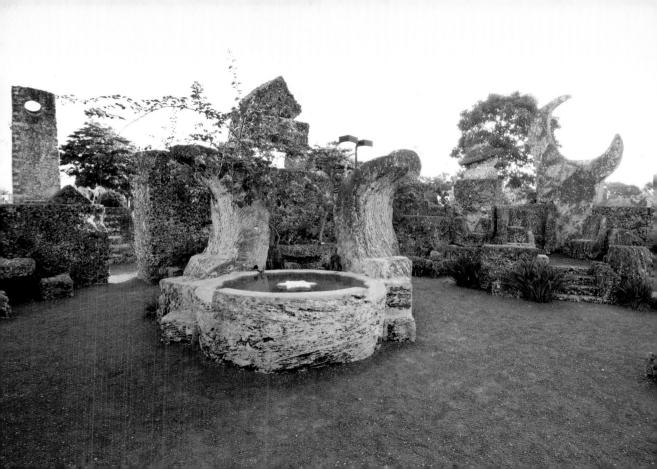

and a 9 ton swinging gate of such balance and precision that it can be moved with the touch of a finger.

Speculation as to how he achieved these gravity-defying masonry marvels abound – theories include extra-terrestrial guidance, links to Ancient Egypt, levitation and magnetism. Upon being asked Edward would simply reply that he "understood the laws of weight and leverage well" or the equally polite but cryptic "It's not difficult if you know."

The castle remained in Florida City until about 1936 when Leedskalnin decided to move and take the castle with him, single-handedly transporting the structure piece by piece to its new home just north of Homestead where it remains today. There Leedskalnin continued to add to his masterpiece and welcomed visitors, charging 25 cents a head to tour the castle grounds.

In 1951, Edward left a sign on the door of the front gate saying "Going to Hospital" and took a bus to a hospital in Miami where he died three days later. Sadly, although thousands have visited Edward's masterpiece, Agnes Scuffs remained in Latvia, aware of the castle but refusing several offers to visit it.

In 1984, Rock Gate Park (now more commonly known as "Coral Castle") was placed on the National Register of Historical Places.

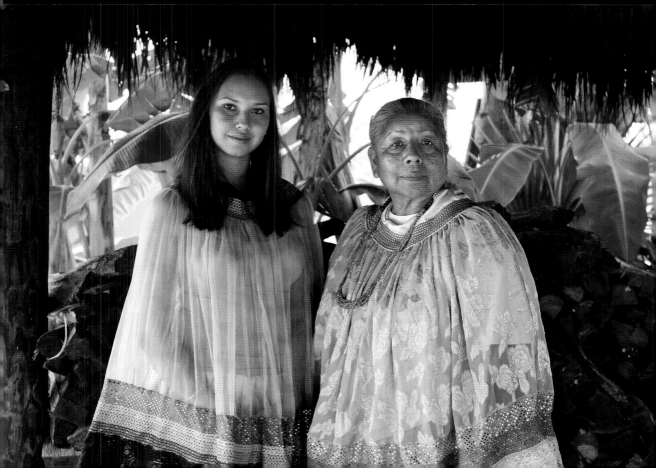

# MICCOSUKEE INDIAN VILLAGE

Just 30 minutes west of the Florida Turnpike, in the heart of the enchanting Florida Everglades, you can enter a world rich in tradition, time honored customs and heritage unlike any other – the Miccosukee Indian Village. More than the native habitat of a proud people, the Village represents the rich culture, lifestyle and history of the Tribe.

The Miccosukee Tribe of Indians is a federally recognized Indian Tribe, originally part of the Creek Nation, an association of clan villages that once inhabited Alabama and Georgia. In 1962, the Tribe was declared a sovereign, independent nation.

Visitors gain valuable insight into the rich culture of the Miccosukee's as well as their traditional lifestyle, and how they have kept the customs and the wisdom of their forefathers alive. At the Indian Village, watch Tribal members create woodwork, beadwork, and patchwork designs. Take in the fascinating Miccosukee Museum, daring alligator demonstrations, scenic airboat rides, and Gift Shop for genuine Tribal arts and crafts and jewelry.

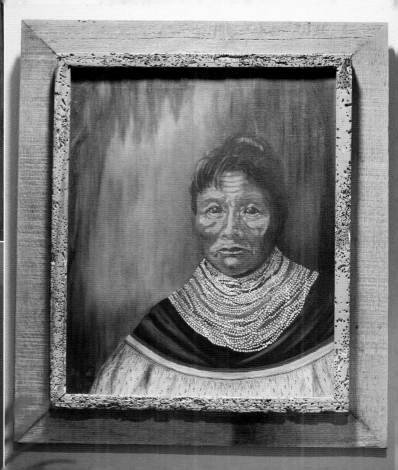

RIGHT: *Located in South Florida, The Miccosukee Indian Reservation is divided into three sections with a total land area of almost 130 square miles. Krome Avenue Reservation, the smallest of these sections, is home to the Miccosukee Resort and Gaming – a spectacular luxury hotel and casino featuring over 1,900 gaming machines, a 1,050-seat bingo hall, and 32-table poker room. Five dining options and two designer lounges are offered, along with a full service European spa & boutique, and a championship golf course just 15 minutes away.*

# EVERGLADES SAFARI PARK

The Everglades is a vast truly wild tropical wilderness preserve teeming with wildlife. It is the only one of its kind in the whole of the Continental United States and covers about 4000 square miles (10 000 square kilometers). Spanning the southern tip of the Florida peninsula and most of Florida Bay, the area has water moving slowly through it from the lip of Lake Okeechobee to the mangrove swamps bordering the Gulf of Mexico and Florida Bay. In 1934 Everglades National Park, encompassing the southwestern portion of the marsh covering 2 354 square miles (6 097 square kilometers) was established. While most national parks are created to safeguard unique geographic features, the main function of the Everglade National Park is to protect the fragile ecosystem.

There are five distinctive habitats in the Everglades: mangrove swamps, hardwood hammocks, pinelands, saw grass prairies and slough. Abundant bird life abounds and it's the only natural environment in the world where both alligators and crocodiles coexist. On the Redlands Trail, the experience with an Everglades Safari Park guide in an airboat, is a wonderful foil to the hustle and bustle of city life. Skimming across the

saw grass-lined waterways of the expansive grassy swamp in an airboat, with a large noisy fan at its rear and a trail of churned up water in its wake, is an experience not to be missed, and the sudden sharp 180-degree turn is invigorating. As the craft stops and the wake settles, the sounds of silence, the anticipation and the ever-present potential dangers of the wild awakens ones primeval hunting instincts as alligators slither into the water and come perilously near.

A variety of biting insects and mosquitoes are present all year round and are especially severe in the hot humid summer months. Bug spray repellent, sunscreen, a wide brimmed hat, appropriate clothes and, for extended stays, bug suits, are advised. Hot summer afternoons are often punctuated by quenching thunderstorms that cool the air and bring life-sustaining water to the environment. Sometimes lightning-ignited fires occur, aiding the regeneration of life-sustaining nutrients.

The Everglades, fragile yet powerful in its existence, is an ecosystem needed for all to survive, not just in this environment but worldwide.

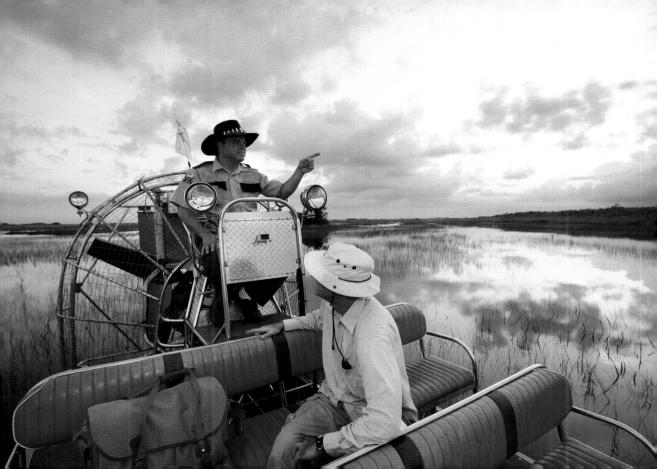

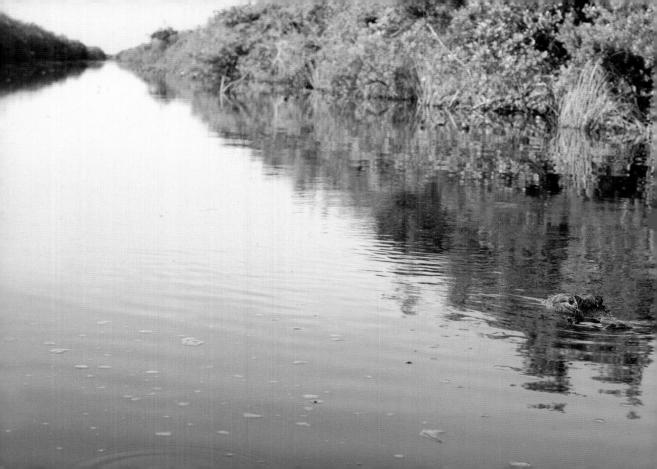

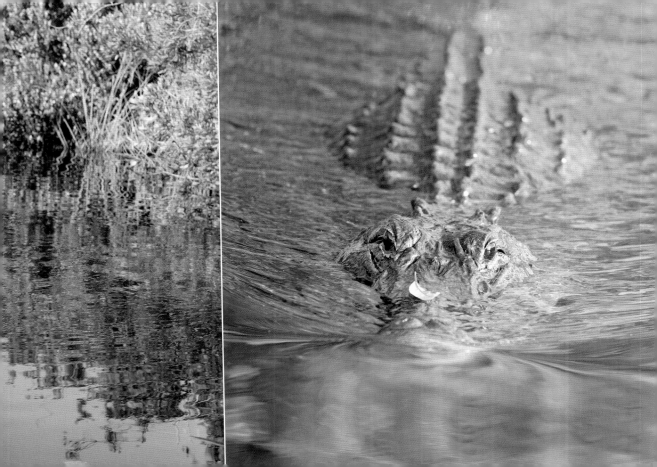

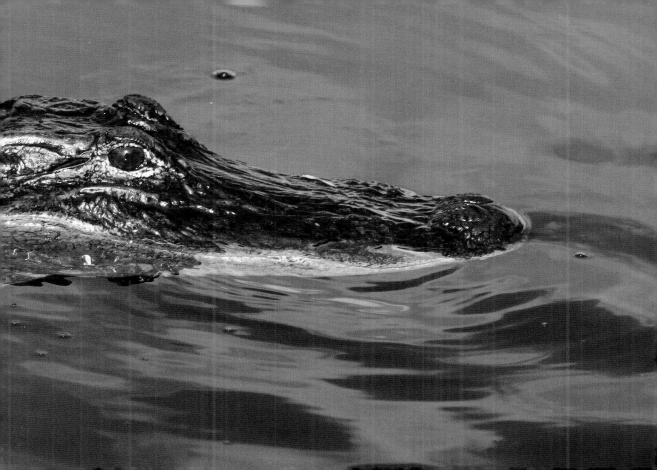

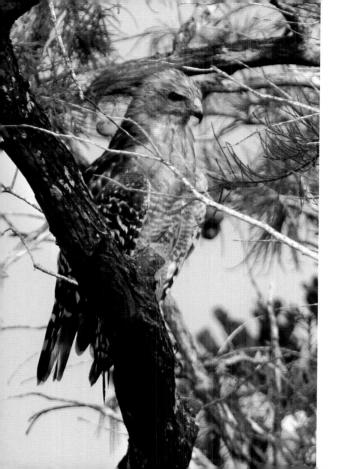

# EVERGLADES ALLIGATOR FARM

Established in 1985 when the State of Florida began permitting the commercial farming of alligators, the popular Everglades Alligator Farm is the oldest of its kind in Dade County. As a real working alligator farm there are several thousand alligators, as well as crocodiles, caimans and even a wide variety of local and exotic snakes from around the world. While the smaller alligators are kept in grow-out pens, the larger alligators reside in natural breeding ponds.

Airboat excursions and guided tours around the farm give visitors the chance to get a close-up view of these magnificent creatures and during informative wildlife shows there are even opportunities to touch and hold real live animals – always a popular experience for the brave!

The abundant wildlife in the area makes each visit a unique experience. Visitors may catch a glimpse of a long-limbed purple Gallinule (*overleaf*) hovering with the elegance of a ballet dancer over its slough habitat or even a Red-Shouldered hawk (*left*) as it surveys the landscape. The area is also home to the Florida Panther (*overleaf*), one of the most endangered animals on earth and Florida's state animal. Weighing from around 77 to 220 lbs (35- 100 kg), Florida Panthers are found in the pinelands and prey mostly on White-tailed deer, wild hogs and sometimes even young alligators.

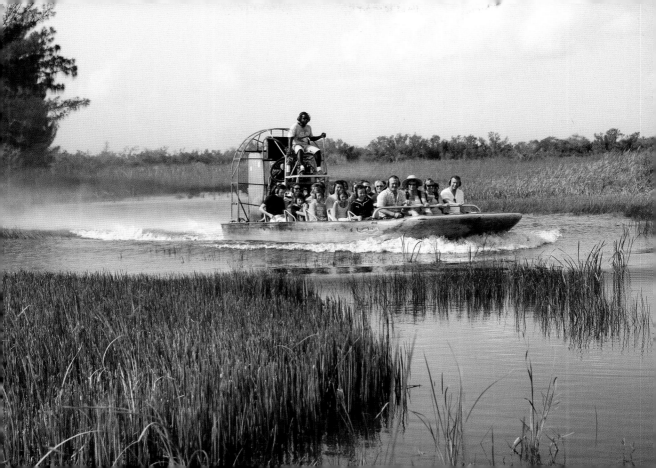

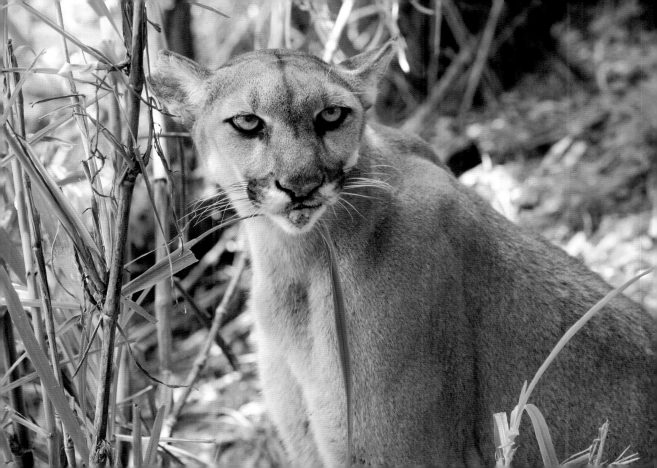

# SELECTED BIBLIOGRAPHY

American Park Network (2009) *South Florida's National Parks*. New York: American Park Network.

Bass, J & Kleinberg, H (2007) *Eat at Joe's – Its story…and its recipes*. Miami: Centennial Press.

*USA Eyewitness Travel Guides* (2004) London: Dorling Kindersley Limited.

McClure, R & Heffron, J (2009) *Coral Castle*. Ohio: Ternary Publishing.

George, Paul S (1992) *The Dr. Paul George Walking Tour of East Little Havana.*

Greater Miami Convention & Visitors Bureau. *Miami – A Sense of Place.*

Greater Miami Convention & Visitors Bureau. *Miami – Pride Celebrated Daily.*

Good Year Brochure (2007) The Goodyear Tire & Rubber Company.

Port of Miami (2009) *Port Directory*. Miami: Seaports Publications Group.

*The Canyon Ranch Story – A passion for Healthy Living.*

The City of Miami (2009) *Municipal Marinas Boater's Guide.*

# INDEX